QUINTESSENTIAL SARASOTA

Cover Image: A bevy of beautiful Miss Florida hopefuls pose in front of the Lido Casino in 1967. This was the site of many beauty pageants. By the decade's end, the casino's deterioration prompted the president of the St. Armands Merchants Association to warn city commission candidates in *The News*, "And if you want to get elected, and if you want to get our vote, you'll do something about it." *Courtesy Sarasota County Department of Historical Resources*

QUINTESSENTIAL SARASOTA

Stories and Pictures from the 1920s to the 1950s

JEFF LAHURD

CHARLESTON · LONDON

History
PRESS

By the same author:

Sarasota, A Sentimental Journey: In Vintage Images
Sarasota—Then And Now
The Lido Casino, Lost Treasure on the Beach
Come On Down, Pitching Paradise During the Roaring 20s
A Passion For Plants: The Marie Selby Botanical Gardens
Quintessential Sarasota, Stories and Pictures from the 1890s to the 1950s Volume II

Published by The History Press
18 Percy Street
Charleston, SC 29403
866.223.5778
www.historypress.net

Copyright © 2004 by Jeff LaHurd
All rights reserved

First edition originally published 1990
Second edition 1991
The History Press edition 2004

Manufactured in the United Kingdom

ISBN 1-59629-023-4

Library of Congress CIP data applied for.

Notice: The information in this book is true and complete to the
best of our knowledge. It is offered without guarantee on the part of
the author or The History Press. The author and The History Press
disclaim all liability in connection with the use of this book.

This book was made possible through a grant from
The Sarasota Alliance for Historic Preservation.

Contents

This book is dedicated to my parents, Fred and Mary Ellen LaHurd, who made growing up in Sarasota such a pleasant memory.

Acknowledgements

I AM GRATEFUL TO FORMER Sarasota County Historian John McCarthy and the late Lillian G. Burns, past president of the Historical Society of Sarasota County, for their invaluable assistance in creating this book. Their suggestions, knowledge of the people, places and events contained in this work, and their efforts in my behalf are greatly appreciated.

I would like to express my gratitude to Pete Esthus, whose Sarasota Lock and Key Shop was a veritable pictorial museum of local history. I hope Pete enjoys his retirement. To Captain Max Frimberger, Joan Dunklin, Mrs. J.C. Cash, Norton's Camera Shop, Sam Montgomery, Deputy Sergeant Bob Snell, Dick Angers, Stan Marable, Tom Bell, Mrs. Anne Marconi, longtime Sarasota police officer Luther LeGette, Christie Bussjaeger and Charles Morris for sharing their pictures and information.

I received help from the 1920s editions of the *Sarasota Times* and the *Sarasota Herald*; 1950s editions of *The News*, the *Sarasota Journal* and the *Sarasota Herald-Tribune*; *The Story of Sarasota* by Karl H. Grismer, Paschal and Paschal Publishers, 1977; *Sarasota Origins*, published by the Historical Society of Sarasota County, 1988; Roger V. Flory's *Sarasota Visitors Guide*; Nina Lewis, formerly of the Sarasota County Archives, who assisted me regularly and always with a smile; Wilson Stiles, former director of the Department of Historical Resources; the late Bob Viol, Charlotte Roberts and Robert Dean of the Department of Historical Resources; and Leonard Peeples, who shares my memories of the Sarasota of the 1950s.

A special thank you to Pam Daniel, editor of *Sarasota Magazine*, and Daniel Denton, president of Clubhouse Publishing, Inc., who first published my writing

in their "Quintessential Sarasota" column and gave me the incentive to persevere until *Quintessential Sarasota: Stories and Pictures from the 1920s to the 1950s* was completed. Thank you also to Ilene Denton, who edited this book.

Abe Namey had enough faith in me to finance this project during its initial stages, and he knows how thankful I am for all his help.

Dan Hughes, archaeologist at the Sarasota County History Center helped me with the third edition of this book and I appreciate his patience.

And finally, to my beautiful wife, Jennifer—thank you.

Foreword

INITIALLY, I INTENDED THIS BOOK to be a look at the small town of my youth—the Sarasota of the 1950s. As I delved deeper into my research, however, studied older newspapers, collected older photographs and talked with people whose recollections extended much further back than my own, the scope began to broaden until it finally encompassed Sarasota from the boom days of the 1920s, the days when many of the landmark sites of my youth were built.

This has been a fascinating and rewarding project. I have always loved Sarasota and felt fortunate to live here. As I look around today though, I am sad to see how many of the landmarks that gave Sarasota its unique charm and character have been lost, often quite unnecessarily.

Today, Sarasota is a beautiful and vibrant city on the move. How much grander it would be if more of its past had been preserved.

Jeff LaHurd

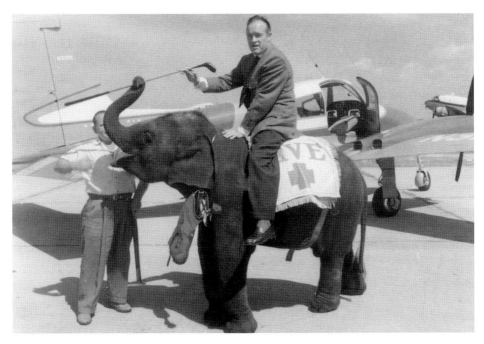

Circus and outdoor sports helped Sarasota earn its outstanding reputation. Here, Bob Hope trades in his caddy for a golf club-carting elephant on a stopover in Sarasota in the late 1950s.

Introduction

THERE ARE TWO SARASOTAS.

Old-timers reminisce fondly about the town that took shape during the boom years of the 1920s and grew slowly through the 1930s and 1940s with the help of a few notable Works Progress Administration projects—the Lido Casino, Municipal Auditorium, post office and airport—and remained intact through the late 1950s.

This Sarasota was a small, quiet resort town that blended the fun and color of being the "Circus City" with the cultural sophistication of great artists and writers who were drawn here by the tropical beauty, pleasant climate and relaxed lifestyle. The beaches of this day were superlative: mile after mile of the whitest sand contrasting vividly with the azure Gulf of Mexico. No high-rise hotels, condominiums or office buildings blocked the view or interfered with the landscape. Beach lodgings were generally small, few in number and inconspicuous. The bay was clean and tranquil. A few dozen boats were anchored at City Pier, prams tacked in the water off Gulf Stream Avenue, and anglers by the score fished from the old Ringling Causeway.

Tall buildings, such as the Palmer Bank, Hotel Sarasota and the Orange Blossom and Sarasota Terrace hotels, were all located downtown where they seemed to belong. The prevalent architecture of the city was Mediterranean and Spanish Mission, compatible with the weather and topography.

Another important characteristic of this period was the communal camaraderie. No one was a stranger. You may not have known everyone by name, but you were sure to know a family member or have a mutual friend. Until Riverview High and

Siesta Key in 1926. Developer Andrew McAnsh built his beautiful Mira Mar Casino on the Gulf-front at Ocean Boulevard in 1925, on what he called Mira Mar Beach. On the Fourth of July, 1923, the American Legion hosted a celebration with auto and motorcycle races on the beach. *Courtesy Sarasota County Department of Historical Resources.*

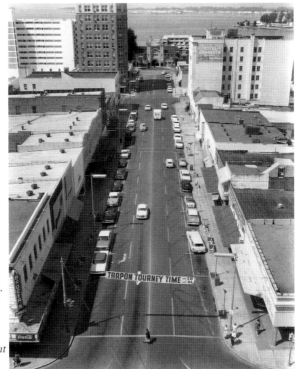

Sarasota grows up. By the early 1960s, when this photograph was taken, downtown Sarasota boasted its first multi-story condominiums. The banner stretched across lower Main Street touts the popular annual Tarpon Tournament. *Courtesy Sarasota County Department of Historical Resources.*

Cardinal Mooney High were established in the late 1950s, everyone went to either Sarasota or Booker High School; they had the same teachers who had taught their older siblings, and in some cases, even their parents. People went to the same two movie houses, saw each other at the beach and shopped at the same downtown stores. The local newspapers—the *Sarasota Times*, the *Herald*, the *Herald-Tribune*, *The News* and the *Journal*—added to the small-town atmosphere by their frequent front-page coverage of local events.

These shared experiences created a sense of security. Crime was not a concern. Windows were left open, doors unlocked. In 1955, the city police kept the peace with 26 uniformed officers and four patrol cars. When Sheriff Ross Boyer took office in 1953, he had only three deputies. By comparison, the 1990 city police force had 187 sworn officers and 60 patrol cars.

The small town of Sarasota had much to be proud of. Not only was it renowned worldwide as the headquarters for the Greatest Show on Earth, it was also one of the most intrinsically beautiful and unspoiled towns in America. We could boast of an extraordinary art museum, a highly regarded art school, a magnificent casino, fabulous beaches, an enviable climate, and a colony of famous writers, artists and performers.

The other Sarasota, today's ever-growing city on the move, began to emerge in 1959 with the departure of the Ringling Brothers circus, the opening of the Ringling Causeway, and especially the arrival of Arthur Vining Davis' Arvida Corporation, which developed Bird Key and later Longboat Key. The county population, which had been only 28,827 in 1950, jumped to 76,895 just 10 years later, and from 120,413 in 1970 to 202,251 in 1980. Even in their most optimistic dreams, Sarasota's earliest developers, land owners and boosters never envisioned how far we were to come.

Today, Sarasota is a wonderful city that offers its residents and visitors an unparalleled lifestyle. It has a wealth of fine shops and restaurants, beautiful homes and condominiums, and stunning beaches with breathtaking views. Few places anywhere can compare.

My hope is that the following stories and photographs will rekindle pleasant memories for longtime Sarasotans, who will happily recall the places they used to shop, the people they used to know and the fun they used to have at the restaurants and lounges that have long since closed. For newcomers who never heard of the Lido Casino, never "cruised" the Smack or ate dinner at the Plaza, I invite you to journey back to yesterday's Sarasota and see the way we were.

Downtown

BEFORE THE ADVENT OF SHOPPING centers, one-stop department stores and mega-malls, there was downtown Sarasota.

It was a special place.

If you stuck a pin in a map at the center of Five Points, within a mile of that pin could be found everything necessary to satisfy your religious, social, recreational, political, medical and shopping needs. Beyond that, you found mostly orange groves, housing developments and the beaches.

During the season—between November and just after Easter—downtown theaters, restaurants, lounges, hotels, churches, stores and the two train depots on Main Street bustled with activity. Lookers and shoppers crowded the sidewalks with a spirit of gaiety.

In the off-season, the atmosphere was relaxed and casual. Some hotels and shops closed; merchants tightened their belts; locals could once again find a vacant table at their favorite restaurant, or a stool at a bar or a seat at the theater. Traffic was less congested, parking spaces could be found, and the slow pace of a small town returned.

Whatever the time of year, downtown Sarasota was friendly. Most of the merchants were locals with close community ties. You knew them by name, and they appreciated your patronage. There were no mute clerks or talking cash registers.

Then, in 1955, the Ringling Shopping Center opened with 13 stores on what had been the Montressor Driving Range, and the move away from Five Points as the center of all our needs began. Maas Brothers, "The Largest Department Store Between Tampa and Miami," followed in 1956, and Southgate Shopping Center followed in 1957 with 20 stores.

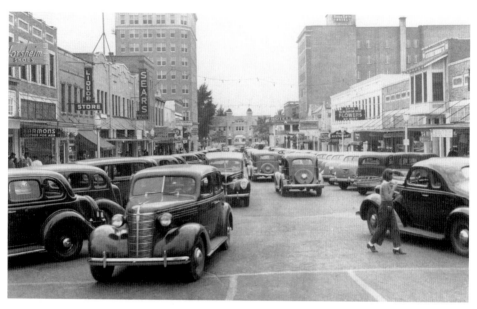

Lower Main Street bustling during a winter season in the 1930s. The Hotel Sara Sota, right, Sarasota's first skyscraper, opened in 1925. The 125-room Hotel Orange Blossom, left, which opened as American National Bank, was converted to a hotel about 10 years later. A 1938 ad read, "From your bedroom or from your living room, you have an ever changing canvas by the Master Artist." The hotel sold in 1946 for $225,000; in 1950 it sold again for more than $300,000. Today, much modified, it is known as the Orange Blossom Tower Condominiums. The nearby Sears Roebuck opened in September 1937 in the Downey Building with "over 100,000 products to choose from." City Hall can be seen at the end of the street. *Courtesy Norton's Camera.*

Downtown Sarasota became depressed in the late 1950s as shops closed and merchants moved to the suburban shopping centers. In the 1980s, the district had started to rejuvenate. While it will never be the same, small, close-knit focal point, it has become a viable shopping and entertainment area once again. As this is written, 29 building projects have either already started or on the drawing board.

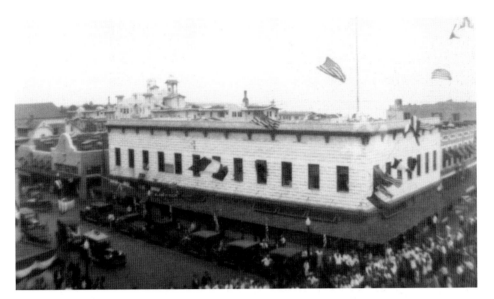

Early downtown landmarks. At Five Points stood the building that housed Badger's Drug Store, built by John Hamilton Gillespie in 1905, then owned by Owen Burns, who bought the Gillespie holdings in 1910. Until it was demolished in 1965 to make way for a 150-space parking lot, it was Sarasota's oldest business and one of its most popular. *Courtesy Sarasota County Department of Historical Resources.*

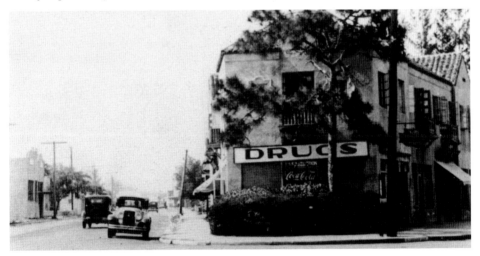

This Little Five Points building, built by Burns, was named Herald Square, after the *Sarasota Herald*, which occupied the building across the street. Joseph P. Privett opened his first drugstore here in 1925. Upstairs were the Pineapple Apartments. The *Herald* noted in 1926 that the building was so well constructed, "the monstrous forces of nature as displayed in the recent hurricane failed to displace one tile from its roof." The architect was Dwight James Baum, who also designed the El Vernona Hotel (later the John Ringling Towers), the Ca'd'Zan and the Sarasota County Courthouse. In 1988, Herald Square was refurbished and now houses shops, apartments and a small restaurant. *Courtesy Charles Morris.*

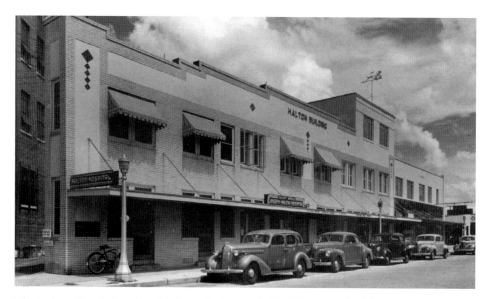

The Halton Hospital, on South Pineapple Avenue behind Kress, was built by Dr. Joseph Halton in 1921. It was Sarasota's only hospital until Memorial was built four years later. In 1951, Dr. Halton was named Sarasota's Man of the Year by the American Legion for performing over 1,600 operations on needy children and for his other civic endeavors. *Courtesy Sarasota County Department of Historical Resources.*

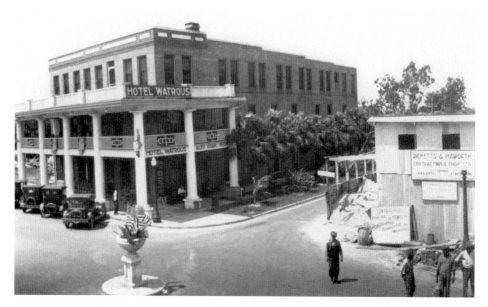

The 34-room Watrous Hotel, later the Colonial, was built on Main Street and Palm Avenue in 1916 by T. T. Watrous for a reported cost of $35,000. In the 1930s it advertised itself as "The House That Makes You Welcome." Sportsmen displayed their day's catch of fish on a rack on the front porch. The hotel was demolished in 1962. *Courtesy Norton's Camera.*

The Hover Arcade, at the foot of lower Main Street, was built in 1913 by Dr. W.E. Hover and two of his brothers, J.O. and Frank B. Hover. It was later purchased by the city and housed City Hall. When Sarasota County was created in 1921, the arcade served temporarily as the courthouse. Over the years, it housed the city's fire and police departments and the clerk's office. The neon sign points the way to another of Sarasota's lost treasures, the Lido Casino. In 1950, the sign was removed, as too often tourists would drive through the archway and onto the City Pier looking for the casino. Both the Hover Arcade and the casino were razed in the late 1960s. *Courtesy Sarasota County Department of Historical Resources.*

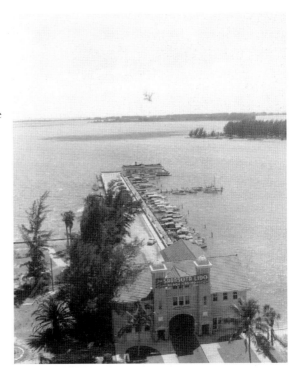

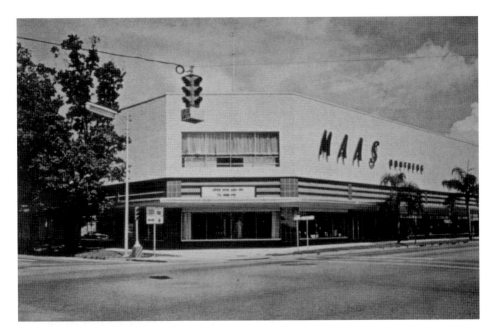

When Maas Brothers opened in 1956, it sold boats and outboard motors, garden supplies, swing sets and medicines as well as appliances and clothing.

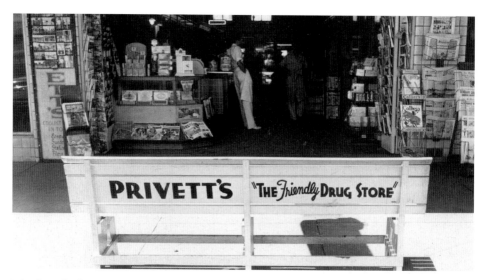

The friendly face of downtown Sarasota: Privett's Drug Store at 429 Main Street in the late 1930s. Twenty years later, it moved to North Orange Avenue, across from St. Martha's Church, where it became a favorite meeting place after Mass. *Courtesy Norton's Camera.*

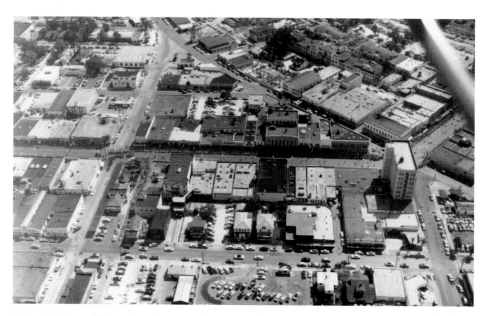

An aerial view of downtown Sarasota taken around 1950. To the right of Five Points is the Palmer Bank, now Southeast Bank. To the left is Lemon Avenue. At Lemon and Main is the Seaboard Airline Railroad Station. Further south, at Lemon and State Streets, is the old police station. As Lemon intersects with Pineapple Avenue, the Bowladrome is on the left, and across the street from it on Pineapple are the VFW building and United First Federal. South of the VFW building is Anderson Ford, today the U.S. Garage office building. The large cluster of buildings in the upper right is the Mira Mar Hotel. *Courtesy Sarasota County Department of Historical Resources.*

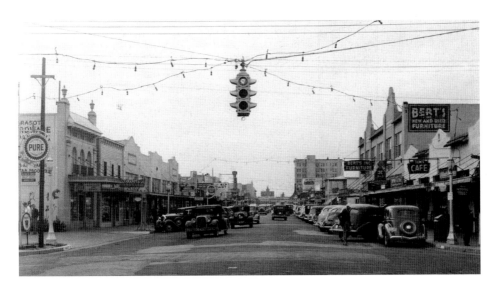

Looking west on Main Street from Orange Avenue in the mid-1930s. Bert's New and Used Furniture, right, offered "every requisite for the fastidious woman." Bert Cohn had been in the furniture business in Sarasota since 1927; he sold the company to Phil Barkus in 1955. At left, in what had originally been the First Trust Company of Sarasota, is Philco Auto Radio. *Courtesy Norton's Camera.*

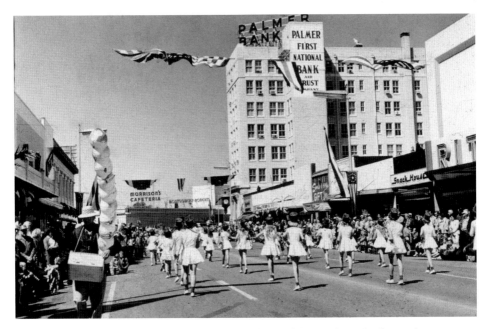

Downtown Sarasota marches into the future. By the mid-1950s, the Ritz Theater has a modern marquee and air conditioning, and signs advertise Morrison's Cafeteria and the Montgomery Roberts Department Store on Pineapple Avenue. Note the clock on the Palmer Bank and the air conditioner units in many of the windows. *Courtesy Joe Steinmetz.*

The American Legion War Memorial

From 1917, when America entered the Great War, until 1954 when it was moved to its current location of Gulf Stream Avenue, one of Sarasota's most treasured landmarks was the American Legion War Memorial. It stood at the center of Five Points, much like the old-time cannons, figures of dashing cavalrymen and statues of generals that stood proudly in town centers all across America.

Initially, the American Legion War Memorial was a simple flagpole. A group of Sarasotans had gathered at Walpole's Red Cross Pharmacy on Main Street, and when talk shifted to the boys who had recently marched off to battle with the Kaiser, someone suggested a memorial be dedicated in their honor. Local contributions were sought, a 12-by-20-foot Stars and Stripes was donated by Mrs. Potter Palmer, and in June of 1917, it was dedicated in a ceremony described as "simple, but very impressive and patriotic."

On November 11, 1928, on the 10th anniversary of Armistice Day, the American Legion War Memorial was unveiled at the base of the flagpole. It was an eight-sided monument of cut stone, approximately 10 feet tall, bedecked with stonefish and eagles. Attached to it was a traffic light that directed cars around Five Points. After World War II, a list of Sarasotans who gave their lives for America would be inscribed under the words, "Oh, the star-spangled banner, long may it wave o'er the land of the free and the home of the brave."

The citywide celebration was a two-day affair with church services, a football game between Sarasota High and the Summerlin Institute of Bartow, a four-card boxing match at the American Legion Hall, a dance at the Mira Mar Auditorium and a rousing parade before thousands of onlookers. Marching down Main Street

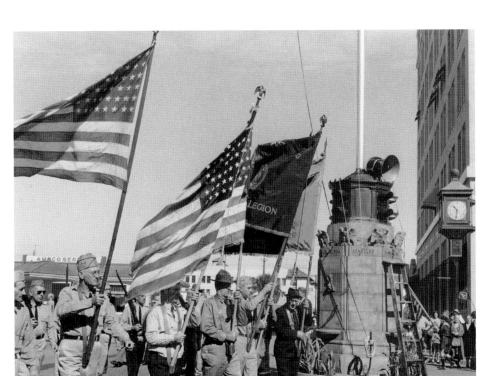

Thousands turned out to see ex-servicemen proudly march the American flag around the War Memorial during this Memorial Day parade in 1941. In a short while, World War II would begin. By the time it ended in 1945, Sarasota would lose 68 of its sons and daughters. *Courtesy Sarasota County Department of Historical Resources.*

in four separate divisions were veterans from the Civil War, Spanish American War and World War I. They were joined by the Daughters of the American Revolution, United Daughters of the Confederacy, numerous fraternal and social organizations, local dignitaries, bands and scouts.

All came together at Five Points for the formal dedication. There were prayers, speeches and the stirring notes of taps played before the unveiling of the monument by God Star mother Mrs. J.P. Currin. Then the "Star Spangled Banner" and "Onward Christian Soldiers" were sung, and the poignant World War I poem, "In Flanders Field," was read ("In Flanders Field the poppies grow between the crosses row on row . . .").

In 1937, at a suggestion that the monument be moved from Five Points, there was a public outcry. Dr. Jack Halton, one of the sponsors of the original memorial, wrote in the *Sarasota Herald*, "If it [the last war] ever does [come], when the smoke of the last battle is cleared away . . . shining out in God's dear sunlight, I pray that the citizens of Sarasota will see the Stars and Stripes waving at the top of this flagpole right where we put it."

The imposing stone monument, honoring the Sarasota men who lost their lives in war, was moved in 1954 to the end of Gulf Stream Avenue. Here, the rededication ceremony. *Courtesy Joe Steinmetz.*

But in 1954, the state road department declared the landmark "a traffic hazard," and it was moved to Gulf Stream Avenue at the foot of lower Main Street.

Today's Memorial Day parades are not as grand as those of the past. The ranks of the soldiers of World Wars I and II, and even of Korea and Vietnam thin out a little more each year. Many of the Gold Star mothers who grieved over the loss of a child in battle have themselves passed away. The sidewalks are no longer filled with flag-waving onlookers out to give thanks to their servicemen. Those sentiments seem to belong to an age when war memorials stood in the center of town squares.

Selling Sarasota, 1920s-Style

ONE OF THE BUSIEST CORNERS in the world in 1925 was the intersection of Michigan Avenue and 12th Street, the heart of Chicago's bustling shopping and theater district. And each day thousands of hurried passersby noticed a giant billboard advertising a place in Florida called Sarasota.

Radio listeners in many Northern cites could pick up the signal of station WJBB, the "Voice of the Semi-Tropics," sponsored by the chamber of commerce to broadcast the virtues of Sarasota all over the country. Brochures put together by real estate agent Roger Flory depicted Sarasota's many attractions, and big ads in newspapers across the nation spread the same message.

The growth of Sarasota is in many ways a testament to the power of advertising. It started in the 1920s, when enticing the rest of the country to come down and sample our salubrious climate, marvel at the tropical foliage, bathe in the magnificent Gulf and just "get away from the mad rush and artificiality of the large cities and not so favored communities" became a local obsession.

And it worked.

The Sarasota of 1920 was scarcely more than a fishing and agricultural village with a population of less than 3,000. By the time the decade ended, the population had nearly tripled, and the town had become a real resort, with splendid hotels, golf courses, beachfront casinos and manicured housing developments.

Attracting visitors to "Spend a Summer this Winter in Sarasota," as the slogan went, was only half the battle. Inducing them to stay and invest was the real challenge.

Salesmen were drawn to Sarasota like metal to a magnet. (Phillip's Bootery recognized the trend when it ran this ad: "WANTED! Fifty Real Estate Men Today.

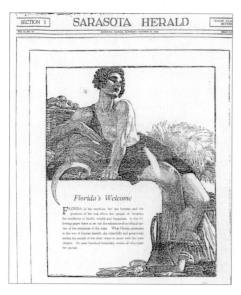

Florida's Welcome

FLORIDA, in her munificence, her sea breezes and the products of her soil, offers the people of America the conditions of health, wealth and happiness. In the following pages there is set out the substance of an official survey of the resources of the state. What Florida possesses in the way of human benefit, she cheerfully and generously invites the people of the other states to secure with her own citizens. An open-handed hospitality awaits all who enter her portals.

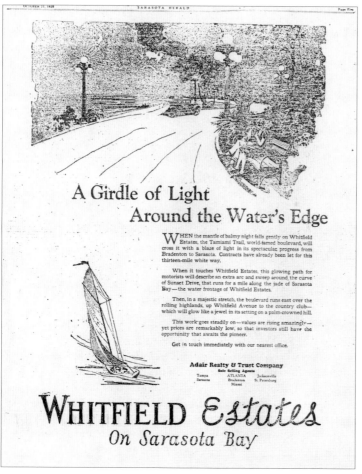

A Girdle of Light
Around the Water's Edge

WHEN the mantle of balmy night falls gently on Whitfield Estates, the Tamiami Trail, world-famed boulevard, will cross it with a blaze of light in its spectacular progress from Bradenton to Sarasota. Contracts have already been let for this thirteen-mile white way.

When it touches Whitfield Estates, this glowing path for motorists will describe an extra arc and sweep around the curve of Sunset Drive, that runs for a mile along the jade of Sarasota Bay—the water frontage of Whitfield Estates.

Then, in a majestic stretch, the boulevard runs east over the rolling highlands, up Whitfield Avenue to the country club—which will glow like a jewel in its setting on a palm-crowned hill.

This work goes steadily on—values are rising amazingly—yet prices are remarkably low, so that investors still have the opportunity that awaits the pioneer.

Get in touch immediately with our nearest office.

Adair Realty & Trust Company
Sole Selling Agents

Tampa	ATLANTA	Jacksonville
Sarasota	Bradenton	St. Petersburg
	Miami	

WHITFIELD *Estates*
On Sarasota Bay

To Try a Pair of These New Style Fine-Wearing Oxfords.") Unencumbered by truth-in-advertising statutes, gigantic one-page ads in the *Sarasota Herald* boldly promised happiness and prosperity for those smart enough to buy. "ROMANCE AND RICHES lie hidden today in the dreamy waters of Casey's Pass. Untold Wealth awaits the investor with vision to see what these sands hold," promised a typical ad. Agents for Indian Beach Estates sought those who would "Share in the Treasure." "Buy now and start a fortune," they said. Here's how Adair Realty described Whitfield Estates: "In a majestic stretch, the boulevard runs east over the rolling highlands, up Whitfield Avenue to the Country Club—which will glow like a jewel in its setting on a palm-crowned hill."

Of course, you had to act fast. As an advertisement for the subdivision Sylvan Shores, Autocrat of All Home Sites, stated, "Twelve hours is ancient history in Florida real estate." The Roger C. Rice Co.'s ad asked, "How Does Your Brain Work?" and warned, "You've got to think, and quickly in these days in Florida."

The prose and promises helped the population soar from 2,940 in 1920 to 8,248 by 1925. Then the crash: from 1926 to 1930, Sarasota grew by only 114 people. But the Sarasota born during those halcyon years was a beautiful town that endured after the land boom had died.

Opposite: "He who hesitates is lost" was the pervading theme of the real estate boom of the 1920s. Often, the same piece of land sold several times before and after lunch, escalating in price with each sale. Many lots were bought and sold this way with no one having any intention of building anything on them. In 1925, the peak of the boom, $4.7 million in building permits were issued. By 1927, it dropped to $470,567, and at the worst of the Depression in 1933, only $51,880 in permits were issued. The *Sarasota Herald-Tribune* chronicled one set of transactions this way: "In 1923, 24 lots were sold on 9th Street [today's 3rd Street] for $66 each. In 1925, eight of them sold again for $45,000 each, and the other 16 later were sold for $600,000. Nothing was ever put on them until many years later when they were sold for taxes."

The Czecho-Slovakian Band

THIS IS A MUSIC-LOVING town, home to many popular bands and orchestras over the years. Merle Evans, who would later distinguish himself as the circus bandleader, directed the city's Municipal Band and gave concerts at the park in front of the Mira Mar Hotel for winter visitors. During the Jazz Age, Van Orden's Sarasotans entertained at the Roof Garden atop the Sarasota Terrace Hotel, while the Mira Mar Auditorium offered "Jazz Galore" by the Ritz Harmony Boys.

During the 40s, the Tropical on lower Main featured Mickey Donna and his orchestra. Rudy Bundy was a hit at several spots, including the Casa Marina Lounge and the M'TOTO Room at the John Ringling Hotel. Lenny Dee, "The Ivory Showman," played the Cypress Room and the Holiday House before moving on to St. Pete Beach.

But of all the musical groups that have come and gone, it would be difficult to find one more colorful or popular than the Czecho-Slovakian National Band.

During the boom years of the 20s, this group appeared at every milestone— the grand openings of the Ringling Causeway and St. Armands Key, the El Vernona Hotel and the Edwards Theater. They performed at the debate when it was decided to sell the city's electric company for one million dollars in order to finance a deepwater port; and they were featured at the first broadcast of radio station WJBB, the "Voice of the Semi-Tropics." They also played at fairs, football games and every kind of high-society benefit.

And how did this group of 26 Czechs end up in a little Florida town? After a triumphant European tour, the band arrived in Ellis Island in 1925, determined to take America by storm. But they were denied entry for lack of means of support.

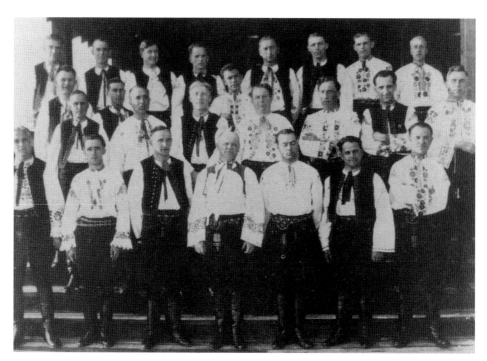

For just about every conceivable public occasion in the 1920s, from store openings to political debates, the enormously popular Czecho-Slovakian National Band would be asked to perform. *Courtesy Sarasota County Department of Historical Resources.*

A call was made to Otokar Bartik, ballet master of the New York Metropolitan Opera, who came to the island to see them perform. He liked them so much he promised to sponsor them on a tour of American cities with large Czecho-Slovakian populations and guaranteed that they wouldn't become public charges.

John Ringling heard them in New York and decided they were just what he wanted to entertain at the grand opening of St. Armands Key.

The press rose to the occasion with the hyperbole of the day. The *Sarasota Herald* proclaimed that booking them for a concert was "one of the greatest accomplishments in the history of the city and a boon for the entire West Coast." In Europe, it continued, "these musicians are reputed to be one of the finest organizations ever formed, its members being recruited from that race of talented artists, the Bohemians."

No wonder that their reception here was spectacular. They were greeted on Christmas Day, 1925, by one of the largest crowds in the city's history, and, dressed in their colorful uniforms, paraded through downtown to Mira Mar Park to give a rousing concert that included jazz, folk songs, marches, native operas and the "Star-Spangled Banner." The paper reported that "the audience sat entranced throughout the entire performance" and "their applause was so great as to necessitate many encores."

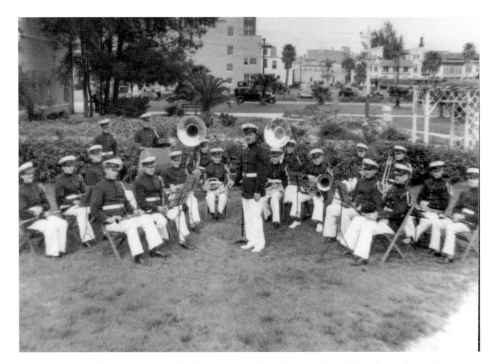

From its earliest days, Sarasota had a band. Here, the City Municipal Band, conducted by Voltaire Sturgis, entertains in Caples Park in front of the Mira Mar Hotel. Sturgis founded the Sarasota High School band, and served as its conductor from 1930 to 1956. *Courtesy Sarasota County Department of Historical Resources.*

Not surprisingly, the band decided to stay around. Under the direction of John Fuchs, they also entertained at Coney Island during the off-season and recorded for Victor Records. It's unclear when they left Sarasota; probably it happened when the land boom that had brought them here in such triumph fizzled and died. Some of them eventually returned to live in Sarasota. French horn player Eugene Pohunek, for instance, went on to perform with the Florida West Coast Symphony.

WJBB — "The Voice of the Semi-Tropics"

I N THE BUILDING BOOM OF the 1920s, signs of Sarasota's prosperity were everywhere—the grand Spanish railway depot, the beautiful new courthouse, even our own radio station: WJBB, "The Voice of the Semi-Tropics." The technology was new, but through a judicious touch with the tuner, the proper atmospheric conditions and a little luck, you could bring the crackling sounds of the rest of the world into your living room.

And what would you tune in? WLW out of Cincinnati offered "The Crosley Cossacks"; WASP (Fort Worth), "The Cliquot Club Eskimos"; WOW (Omaha) "The Maxwell Hour"; WGN (Chicago), "The Ipana Troubadors." And from New York, to the consternation of many mothers, came Earl Carroll, "the unseen sheik with the radio love-voice."

Such was the fare when WJBB—1260 on the dial—signed on from the Hotel Sarasota Terrace (today's county administration building) on the evening of December 11, 1927, with a schedule that included vocal selections, the Czecho-Slovakian National Band and speeches.

Entertaining the locals, however, was not the only or even the primary purpose of the station. Its main objective was to broadcast the virtues of Sarasota—"Where Summer Spends the Winter"—to the rest of the country.

The *Sarasota Herald* regularly informed its readers of how far the broadcasts were carried, and boxes of Florida oranges and grapefruits were offered as inducements for listeners to inform the station where its signal had been heard. A listener from Salem, Oregon, got into the spirit, writing, "Sarasota seems to be a live city and will surely drive great benefit from such programs."

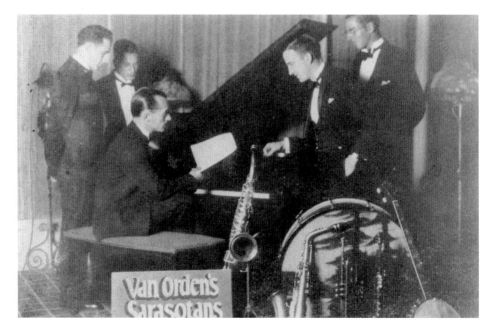

WJBB beamed across the nation the melodious music of two local bands, Pfeiffer's Melody Kings and Van Orden's Sarasotans, shown here. The city's first radio broadcasting studios were in the Sarasota Terrace Hotel. *Courtesy Sarasota County Department of Historical Resources.*

Along with the regular schedule, remotes were broadcast from the El Vernona ("Sarasota's Social Rendezvous"), the Mira Mar Hotel ("the Gem of the West Coast"), the Edwards Theater; musicales from the Whitfield Country Club; organ recitals from Ca'd'Zan, and descriptions of the animals and acts from the Winter Quarters—along with Foo Foo the clown reading children bedtime stories.

By January 19, 1928, the *Herald* could report that WJBB had received 1,200 letters and 172 telegrams from 42 states and nine points out of the country, from as far away as Honolulu.

As the *Herald* editorialized, "taken all in all, WJBB is about the biggest and best thing to come down the pike for Sarasota."

The station was owned by Jack Dadswell, editor and president of a Florida magazine, the *Financial Journal*. The chamber of commerce was responsible for all programming; community leaders formed the announcing staff; and community talent provided the entertainment, which included Claire Louise Binz, whistler; Happy Jack Haynes, piano and pipe organ; Mrs. J.W. Johnson, pianist and entertainer; Mrs. Randolph Dickens, soprano; Dr. J.W. Johnson, entertainer; and the popular Merle Evans Municipal Band.

If all that weren't enough to keep you happily listening at home with the family, you could always go down to the Edwards Theater and for 10 cents see "The Racing Romeo," starring Red Grange: "A crashing symphony of wildly whizzing wheels and wildly beating hearts."

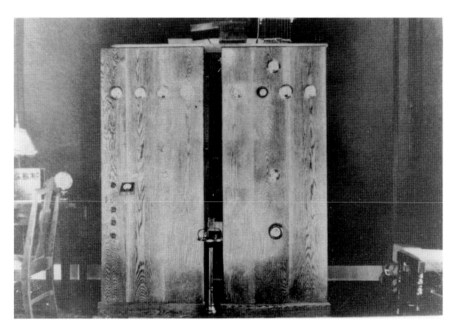

These station transmitters managed to send broadcasts as far away as Honolulu. *Courtesy Sarasota County Department of Historical Resources.*

Shown here are the transmission towers and control house in Payne Park in the 1920s. *Sarasota County Department of Historical Resources.*

A Short History of Sarasota Tourism

S ARASOTA WAS FATED TO BECOME a tourist haven. The climate was salubrious, the scenery was tropical, the pace was relaxed and the atmosphere tranquil; the beaches pristine; and for sportsmen, the fishing was unequaled.

In the early decades of the century, those wealthy enough to afford to winter in the tropics began to discover this idyllic retreat from Northern winters. Many of them—businessman Ralph Caples, Chicago socialite Mrs. Potter Palmer, developer Owen Burns, circus magnate John Ringling—fell in love with the area, stayed on and actively helped Sarasota to develop.

The next influx of tourists included members of a loosely federated organization, the Tin Can Tourists of the World. Formed after World War I "to unite all auto campers," they came south in modified flivvers, their tin can emblem perched proudly atop each hood. Some areas gave the Tin Can Tourists the cold shoulder, because they mistakenly believed they all were poor. The group ultimately chose Sarasota as its convention site, and through the 30s and 40s they gathered in Payne Park by the thousands. (Today, members of a similar group, who tour the country trailing silver Airstreams, also gather in Sarasota every February.) The Tin Can Tourists gave Sarasota an annual economic boost and took home rave reviews.

World War II brought numerous servicemen from all over the country to train at the Sarasota and Venice air bases. They weren't true tourists, but their stay here convinced many to return with their families when the war ended.

Local businessmen and civic boosters advertised Sarasota vigorously. Harry Higel was one of the first to mount a national campaign. His "Siesta on the Gulf"

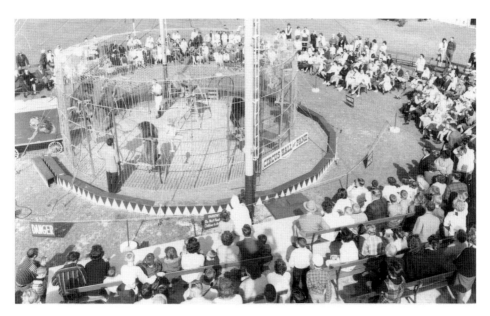

The Circus Hall of Fame, on North Tamiami Trail across from the airport, was a popular tourist attraction. Opened in 1956, its seven buildings had 29,000 square feet of exhibit space for circus memorabilia. There were daily circus performances. It closed in 1977. *Courtesy Joe Steinmetz.*

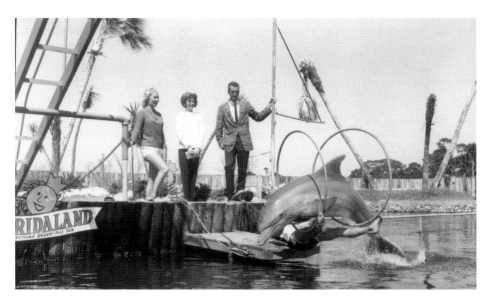

Philip C. Smashey's Floridaland ("Everything Under the Sun") was located in Osprey behind the Holiday Inn that was built in conjunction with it. Fronting both U.S. 41 and Little Sarasota Bay, the well-known tourist attraction boasted a deer park, ghost town, animal farm, shoot 'em up show, Indian village, Golden Nugget Saloon with Can-Can dancers and a dolphin show. The Southbay subdivision now occupies the site. *Courtesy Sarasota County Department of Historical Resources.*

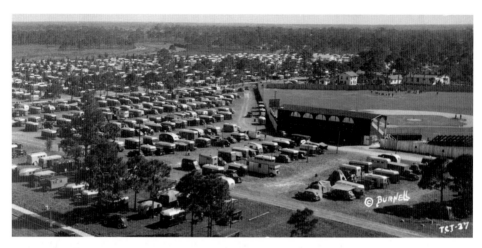

Thousands of Tin Can Tourists gathered each winter around Payne Park, beginning in 1931. Their creed was "To unite fraternally all auto campers. To provide clean and wholesome entertainment at all campfires. To help enforce the rules governing all campgrounds." *Courtesy Sarasota County Department of Historical Resources.*

brochure gave a comprehensive overview of Siesta Key as "a haven of rest where the waves . . . lap on the long, white clear beaches." In the 1920s, the Florida Development Board sponsored Post Card Week and offered a gold cup to the town that sent out the most cards. Radio station WJBB, "The Voice of the Semi-Tropics," broadcast the virtues of Sarasota to listeners as far away as the Midwest, Idaho and even Honolulu.

The Ringling Brothers and Barnum & Bailey Circus moved here in the late 20s. People all over the country saw its press releases and programs, which touted Sarasota as "The Circus City." Many other organizations promoted the city, including the chamber of commerce, the *Sarasota Herald* and groups such as the Backers of Sarasota, which urged citizens to "spread the news in every letter you write: Sarasota is truly the Year-Round Playground, the hub from which radiate all the points of scenic and historical interest with which the West Coast abounds."

Inviting newcomers was only part of the game plan. Providing them with quarters, entertainment and attractions worthy of a return visit were equally important.

By the early 1920s, neither the Belle Haven Inn nor the Watrous Hotel, on opposite corners of Main Street and Palm Avenue, was adequate to meet the caliber of guest for which Sarasota backers were vying. Not until 1922-1923, when Andrew McAnsh built the Mira Mar Apartments, Hotel and Auditorium, which offered "the atmosphere of cheerfulness and refinement," did Sarasota have a world-class complex. Shortly thereafter, spurred by the real estate boom, numerous hotels and apartments followed.

Entertaining the yearly migrants has taken many forms. The City Municipal Band and the Czecho- Slovakian National Band, hired by John Ringling, gave free concerts in the park in front of the Mira Mar Hotel. The Sara de Sota Pageant

lasted a week each year and drew thousands to the colorful parade that celebrated the legend of Sara de Sota and the Indian Prince, Chichi Okobee.

Outdoorsmen came for the fishing. The bay and Gulf teemed with tarpon, kings, pompano, snook and many other species. Catches were reported on the front page of the *Sarasota Herald*. A sample: "Walter B. Olsen caught 20 tarpon in 12 hours, ranging in weight from 45 to 155 pounds, in the Gulf off Sarasota." Strings of fish were proudly displayed at City Pier and at the guests' hotels. (In the annual Tarpon Tournament in 2004 the winning catch—it was the only catch— was 29 pounds.)

The Ringling Brothers Circus Winter Quarters was opened to the public at the end of the 20s and soon became our most popular attraction. By 1940, it pulled in 100,000 "children of all ages" every year.

In the mid-30s, one of Sarasota's most colorful characters, Texas Jim Mitchell, opened the Sarasota Reptile Farm and Zoo on Fruitville Road. Texas Jim, a former Hopi Indian dancer in a Wild West show, and his wife Mae reportedly started the venture with $14. The attraction expanded almost every year, and by the late 50s, its five acres were filled with alligators, crocodiles, snakes and numerous exotic animals. Texas Jim never forgot his roots. When the weather got particularly dry, he would don his Indian outfit and do a rain dance around the War Memorial at Five Points.

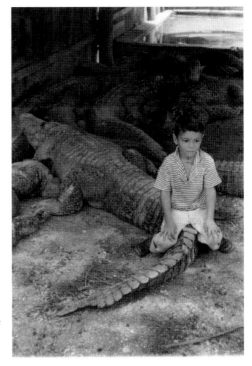

An up-close-and-personal look at "Texas Jim" Mitchell's Reptile Farm and Zoo, which opened in 1935 on Fruitville Road near Tuttle Avenue, the site of today's Pen West Park office complex. Before settling in Sarasota, Texas Jim had toured as a Hopi Indian with a Wild West show. The brave lad on the alligator is the author's younger brother, David. This picture flabbergasted my mother who wasn't there when someone chose to put young David in the pit: "It wasn't me, mom." *Jeff LaHurd*.

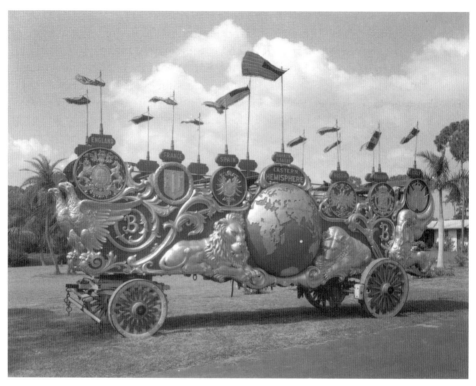

The Circus Hall of Fame centerpiece was the Two Hemispheres band chariot. Twenty-four to 40 horses were required to pull the 10-ton vehicle. The magnificent wagon had been built for Phineas T. Barnum in 1896 for a reported cost of $40,000. In 1944, Colonel B.J. Palmer found it abandoned at the Iowa State Fairgrounds and had it restored to its original brilliance. He turned it over to the Circus Hall of Fame when it opened in 1956. *Courtesy Sarasota County Department of Historical Resources.*

The Ringling Museum and mansion were opened to the public in the 30s, and the ever popular Jungle Gardens was dedicated on December 31, 1939. Horn's Cars of Yesterday (now Sarasota Classic Car Museum) followed in the early 1950s.

In 1956, the Circus Hall of Fame opened. It was a giant complex that housed circus memorabilia, collections, circus wagons and had arenas for live performances.

Another theme park, Floridaland ("Everything Under the Sun"), opened in Osprey behind the Holiday Inn built in conjunction with it. The short-lived attraction had an animal farm, a Western Town with a shoot-'em up show, a Golden Nugget Saloon with Can-Can girls and a dolphin show.

The beaches, of course, have always been the favorite tourist spot. In the 1920s, Siesta boasted the Mira Mar Casino Club, "Sarasota's Exclusive Night Club"; Robert's Casino; the Bay Island Hotel; and the Gulf View. In 1940, the most popular beach attraction of all, the Lido Casino, was built. For 29 years this Art Deco fun spot attracted residents and tourists.

Many of Sarasota's tourists have been celebrities. Will Rogers, Eddie Cantor, Tom Mix and even Elvis Presley performed for appreciative audiences here. When *The Greatest Show on Earth* was filmed in Sarasota in 1951, Cecil B. DeMille brought the most popular stars of the day—Dorothy Lamour, Cornell Wilde, Charlton Heston, Betty Hutton and Gloria Grahame—and their goings-on were duly reported by "Main Street Reporter" Helen Griffith and even featured on the front page: "Movie Stars Take 200 Mackeral off Big Pass."

Other notables who have visited make for a diverse list: Albert Einstein, Eleanor Roosevelt, Tommy Dorsey, Prince Rainier, Jim Thorpe, Cary Grant, Dan Rowan, Bob Hope, Mickey Spillane, Milton Berle, Sammy Davis, Don Johnson, Audrey Hepburn and Morgan Fairchild.

Despite development and changes, Sarasota continues to attract visitors from all over the globe. Many settle here permanently, and the cosmopolitan atmosphere of this small city owes much to their diversity and influence.

The Prohibition Era

T HE PUBLIC'S RESPONSE TO PROHIBITION was to consume more booze than ever before.

In New York, for instance, 15,000 nightclubs had multiplied into 32,000 speakeasies by the time the "Noble Experiment" came to an end. This was, after all, the era that has been tagged the Roaring 20s—fast times noted for such singular diversions as wing-walking, goldfish eating and flagpole sitting; for wild dances such as the Black Bottom and the Charleston; and for lurid, tabloid journalism. In such an atmosphere, Prohibition gave rise not to teetotalers but to bathtub gin, bootleggers and speakeasies.

Nightlife in Sarasota followed the national tempo. The Gulf View Inn advertised,

> *HEY! TAKE A TIP—MAKE A DATE WITH THAT GORGEOUS GAY GIRLIE TO DO*
> *THAT HAPPY, SNAPPY GRAB-A-CHAPPY CHARLESTON. Music by DALE TROY and*
> *His Orchestra. (Makers of the Fastest Steppin' Jazz Steps Ever Stepped.)*

Then, as now, the Gulf Coast was rife with smugglers, sellers and, of course, buyers of the contraband of the day. Their ongoing battle with the Feds was frequently and colorfully reported in the *Sarasota Herald*. "Queen of Booze Buccaneers of the Bahamas" was arrested shortly after she had "abandoned rum-running to seek new adventures in real estate." A few weeks later: "A woman believed to be queen of a gang of bootleggers and dope peddlers arrested. Liquor and cocaine valued at $15,000 seized." One of Sarasota's own, C.H. Thomas,

"alleged wealthy bootlegger," pled guilty to charges of possessing liquor and was fined $500. He was said to be the head of a huge ring that "conducted business with high-priced automobiles."

The attitude of local officials toward the purveyors of demon rum was at best ambivalent. Sheriff L.D. Hodges was the chief law-enforcement officer, and he and his deputies were alternately praised and criticized for stemming the flow—or not.

Sometimes Hodges would come down hard on the bootleggers. "BOOZE SELLERS FLEE AS DRIVE ON THEM LOOMS." The paper went on to report that after Sheriff Hodges warned he expected to have bootleggers "in custody within 24 hours, certain of gentry in Sarasota have gone to other parts. Friday night was believed by certain residents to be one of the quietest nights the city has seen for many months." It was but a temporary lull, and many Sarasotans blamed Hodges.

In 1925, a grand jury urged the dismissal of three deputies and severely criticized the sheriff's law-enforcement record. The practice of allowing liquor violators to pay their fines and avoid their time at hard labor was condemned, and the jury

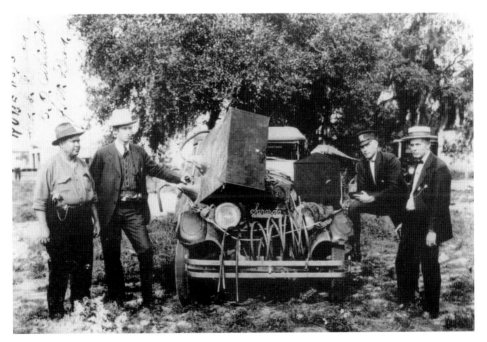

Raids on "speaks" and "stills" were common here during the tumultuous 20s, but enforcement of the Prohibition laws was inconsistent at best. Sarasota Sheriff Leon Davis Hodges, who served from 1922 to 1929, was criticized by a 1925 grand jury that called for the ouster of three of his staff. Standing in front of this 1927 Buick with the fruits of a liquor raid atop the hood are, from left to right, Jailer Reuben Hays, deputies George C. Duncan and Belden Oliver Whitted and Chief Deputy John Dean.
Courtesy Sarasota County Deputy Bob Snell.

went on to note that "certain officers have acted in a very suspicious manner with reference to the removal of liquor from the county jail." No deputies were fired, and, perhaps in an attempt to salvage his reputation, within a few months Chief Deputy John Dean set a record in the state for liquor raids. Deputy Dean also began the then-novel practice of using an airplane for surveillance.

These efforts and a press that lauded Sheriff Hodges' "enviable reputation" notwithstanding, another grand jury convened in 1927, and, after an exhaustive investigation, charged that "the liquor traffic in Sarasota Country is organized and protected." Although the jury called for the removal of Sheriff Hodges, he finished his term in office.

Hodges was followed in 1929 by Sheriff W.A. Keen. One of his first acts was to arrest the nefarious moonshiner, Home-Brew Daddie; then he mounted a raid that netted a cache of "better brands," brought into town for the revelers at the Sara de Sota pageant. The new sheriff warned bootleggers to expect "persistent efforts on my part to stamp out liquor, for I am going after them with all the power at my command."

For four more years, the battle went on: raids, arrests, confiscations and criticisms. In 1933, Prohibition finally yielded to public sentiment. By then the universal password to a good time—"Joe sent me"—had been replaced by a new and more disturbing phrase—"Brother, can you spare a dime?"

The John Ringling Towers

IF YOU WERE FORTUNATE ENOUGH to vacation in Sarasota in decades past, and rich enough to choose any hotel you wished, you would have made reservations at either the Mira Mar or the El Vernona.

From the roaring 20s to the tranquil 50s, the Gem of the West Coast, as the Mira Mar Hotel was known, and the Aristocrat of Beauty, as the El Vernona was called, personified Sarasota at its best.

But eventually each hotel would fall on hard times. The Mira Mar was reduced to rubble in 1982, and the John Ringling Towers, as the El Vernona came to be called, met the same fate sixteen years later. Once the pride of Sarasota, the grand old hotel was left to rot away in the sun, devoid of even the most rudimentary protection and upkeep, it became a haven not for the world's rich and famous but for the city's derelicts.

The hotel's Spanish design was the work of noted architect Dwight James Baum, who was also responsible for our courthouse and Ca' d'Zan. It was built in 1926 for Owen Burns, Sarasota's wealthy landowner and developer, who named it in honor of his lovely wife Vernona.

No expense was spared in construction or furnishings. In return for the nearly 800,000 "golden dollars poured out with a lavish hand," the *Sarasota Herald* reported, Mr. Burns and Sarasota received a five-story, 150-room hostelry where "the exotic charms of Spain and the metropolitan grandeur of the new World have been deftly woven together to create a harmonious whole,

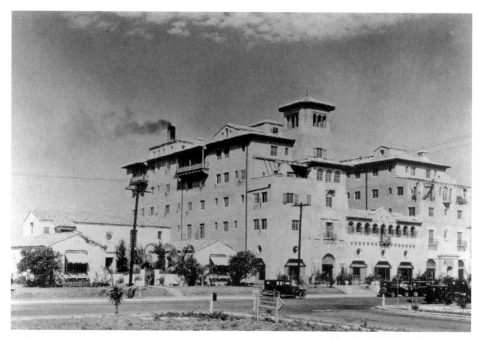

Built by Sarasota developer Owen Burns, the Mediterranean Revival El Vernona Hotel represented all that was golden about that amazing boom time in Sarasota's history. Next door is Burns' office, which was later purchased by United Press president Karl Bikel and converted into his residence. The hotel was demolished in 1998, the Bikel home was razed a short time later. *Courtesy Sarasota County Department of Historical Resources.*

which is more pleasing to the eye than any hotel among Florida's palatial ones."

The formal opening was a suitably grand affair held on New Year's Eve of 1926. Hundreds of invitations were sent out and a full-page ad cordially invited the public for the $10-per-person dinner and dance. At 8 p.m., the gala began and continued throughout the night with "such jollification as had seldom if ever been seen or heard in Sarasota."

When the stock market crashed in 1929, Owen Burns fell on hard times and the El Vernona went into receivership, ultimately to be taken over by John Ringling, whose own grand hotel, the Ritz Carlton on Longboat Key, was never completed. Except for the name change to the John Ringling Hotel and a switch in managers, the hotel remained basically the same until Ringling's death.

His nephew, John Ringling North, took over in 1936 and gave it the colorful atmosphere of the circus. An actual giant, suitably outfitted as a brass-buttoned doorman, was posted outside; high-wire and trapeze acts were performed in the great room (the magnificent chandelier that had formerly hung in the mansion of John Jacob Astor was cranked over to one side). There were even animal acts, like the noted equestrian, Captain Heyer, and his magnificent steed Starless Night.

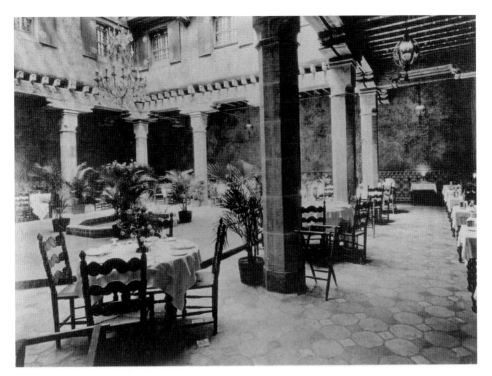

The elegant El Vernona dining room. *Courtesy Sarasota County Department of Historical Resources.*

The 1950s were the last years of the hotel's greatness. By 1964, it had become the John Ringling Towers, its 150 rooms converted into 84 apartments and 2 penthouses. It also housed an Indian restaurant and the M'TOTO lounge. The building passed through a series of owners, each announcing grand plans to restore it that never materialized. The majority of the city commission always seemed more inclined to tear it down rather than be pro-active in having it restored. The John Ringling Centre Foundation was formed and fought long and hard to save the building. The Sarasota Alliance for Historic Preservation also fought its destruction; both groups generated much public support. But in the end, even a plan by the prestigious Crowne Plaza Hotel chain to renovate it and turn it into a "boutique hotel" failed. Sadly for many, the *Sarasota Herald*'s assertion in 1927 that "[The El Vernona] is calculated to become and remain in the minds of the people who see it, 'a thing of beauty and a joy forever'" proved not to be true and the grand old hotel was razed.

The Ringling Causeway

THERE IS NO TRACE TODAY of the original John Ringling Causeway—the one built by the great man himself. A drive to its former starting place at the end of Golden Gate Point reveals not a clue that here was the gateway to a bridge that spanned both the bay and the length of time that Sarasota was a small town.

It was as much a bridge for people as for cars. Not many years ago, when word spread that the fish were running, both sides of the bridge quickly filled with anglers ready to reel 'em in. At times like that, many downtown stores would lock their doors as the merchants grabbed pole and tackle box and heeded the call.

Of course, Ringling had more in mind for his bridge than to serve as a platform for avid fishermen; more, too, than an altruistic desire to open Lido Key to the automobile. He built the bridge, first and foremost, to help sell his island development, Ringling Estates.

Construction began on January 1, 1925, and continued without delay until the bridge was completed exactly one year later. When John Ringling started his green Rolls Royce at 1:30 on the afternoon of January 1, 1926, for the maiden trip, he traversed a bridge heralded as one of the greatest engineering accomplishments in the South. Materials included 25 railroad carloads of cement, 1,000 kegs of nails, 96 loads of timber and lumber, 35 loads of gravel, 20 loads of sand and numerous miscellaneous items. The bill was reported to have come to between $750,000 and $1 million.

The finished product was a splendid sight. Its white, ornately carved railings stretched proudly 8,300 feet to "the tropical island which Mr. Ringling has

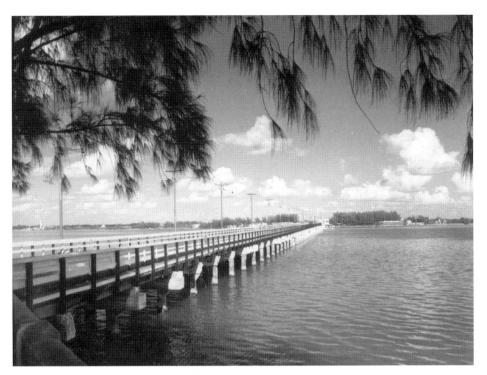

Looking east on the Ringling causeway after its ornate cement railings had deteriorated and had been replaced with wood. The walkway was added sometime after construction, to accommodate fishermen. *Courtesy Joe Steinmetz*.

transformed into what is perhaps the greatest development in the state," as the *Sarasota Herald* described it.

Sarasotans had closely followed the bridge's progress. Finally, on February 7, 1926, they got their chance to take a trip across.

For the grand opening festivities, the Czecho-Slovakian band, hired by Ringling a few months earlier, gave rousing concerts in an especially constructed band shell. Hourly bus transportation was scheduled to and from the Ringling headquarters on Main Street. Before the day was over, thousands from all over the state had poured onto the key to marvel at what the paper called a "tropical Utopia" of broad boulevards, canals, palm trees and "alluring parkways."

In June of 1927, on the day that Lucky Lindy was being greeted by millions of hero worshippers in New York City, the *Sarasota Herald's* headline blared, "RINGLING GIVES CAUSEWAY TO CITY" and the story said, "There are no words adequate with which to express our appreciation for this wonderful donation . . . It will only be natural that beautiful homes and fine estates will be erected on the keys. And when this is done, Sarasota will be the cynosure of all America and the world."

But by 1959, the beautiful causeway had sadly deteriorated. The railings had broken off and been replaced with wood, and the span itself was not up to

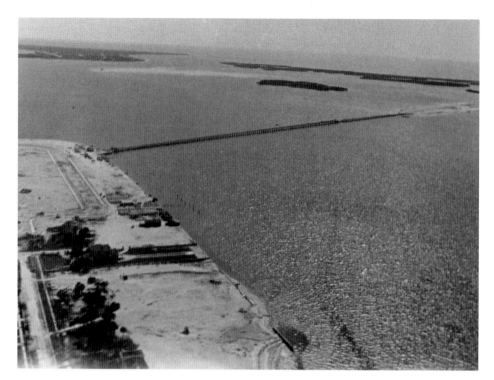

Stretching from a recently dredged Golden Gate Point, the causeway to Ringling Isles is partially completed in this 1925 photograph. At 26 feet wide, the bridge was said to be the widest of its type in Florida. Circus impresario John Ringling built and donated the bridge and the upkeep that went with it to the city; as he was away much of the time, he left the construction of the bridge and development of St. Armands and Lido Keys to Owen Burns, who was then vice president of Ringling Estates, Inc. *Courtesy Sarasota County Department of Historical Resources.*

the rigors of modern traffic. The quiet days of small-town Sarasota were just about over; a faster-paced era was soon to begin, and for it, the current Ringling Causeway was constructed.

The next time you speed across that bridge on your way to St. Armands Key and "the cynosure of all America," look over to your left, to the end of Golden Gate Point. Thirty years ago, there was a beautiful bridge over there, its white railings shining in the sun, its pavement lined with contented fishermen.

The Ringling School of Art and Design

For over 75 years, the Ringling School of Art and Design has stood as an educational and cultural cornerstone in a community that prides itself on its relationship with the arts.

The building that houses the school was opened as the Bay Haven Hotel in time for the winter season of 1926. With 70 outside rooms, a dozen ground-floor shops and "one of the most pretentious and beautiful lobbies in Florida," the hotel was advertised as "home-like in atmosphere and particularly pleasing to tourists." An article explained that builder C.V. Coleman had set the room rates at $2 to $3 a day, year-round, as he was "more anxious to make friends for the hotel than to make money."

And in a few years, there was little money to be made. The real estate bust and the Great Depression had arrived, and the hotel sat vacant and for sale.

Its proximity to the Ringling Art Museum—and its bargain price—appealed to John Ringling, who was interested in starting an art school. Dr. Ludd Spivey, president of Southern College, and Vernan Kimbrough, who would preside over the school until 1971, teamed up with Ringling, who purchased the hotel for taxes and insurance payments. Ringling raised the $45,000 necessary for renovations, and The School of Fine and Applied Art of the John and Mable Ringling Art Museum became a reality.

On October 2, 1931, in the courtyard of the museum, 3,000 proud Sarasotans gathered to "mark a new epoch in the cultural history of the South." Speeches were made by United States Senator Duncan Fletcher, Bishop Moore of Texas, local dignitaries and John Ringling, who turned his magnificent museum with millions of dollars' worth of paintings over to the new school.

By the second year, enrollment had climbed to 124 students taking art courses and 141 in the junior college. The school also managed to field a basketball team, known, naturally, as The Painters.

But the liaison with Southern College ended in 1933, and while the school gained its independence, it also faced some rough years. Enrollment dropped, salaries were cut to the bone and staff had to move into the dorms to make ends meet. By 1937, the crisis passed. Thanks to the skill of Dr. Kimbrough and the sacrifices of the faculty, the school was once again on solid ground. The junior college and music courses were eliminated and the school adopted "a philosophy to teach very basic art fundamentals in order to give a strong basis for becoming exceptionally talented professional artists." As the school brochures noted, "No finer place can be found in the world for the study of art than Sarasota."

Always active in civic affairs, Dr. Kimbrough was elected mayor of Sarasota in 1938. During his 40-year tenure as president of the school, the school-sponsored Beaux Art Ball became one of Sarasota's most popular social events, and fashion shows to raise funds for the school were held at the Florida Theater. The community interaction continues with art shows, community classes, a summer camp for kids and the annual polo match and party.

The old Bay Haven Hotel is still in use, a visible reminder of the school's roots, but the campus now covers 30 acres, has 14 buildings and serves over 500 students. Courses have been updated and all the requirements necessary to earn a Bachelor of Fine Arts degree in five disciplines are available.

The future of the school is secure. As John Ringling intoned on that October day so many years ago, "For Though Life is Short, Art is Long."

The Founders Circle of the Sarasota Garden Club

B Y 1927, THE FLORIDA REAL estate bust had demoralized Sarasota. The same town that had been giddy with the excitement of transforming itself into a glitzy resort was now somberly realizing that the party was over. Building stopped, businesses closed, downtown stores sat vacant, the stream of new residents quit flowing and local morale slumped.

In May of that year, a group of about 30 civic-minded men and women— Owen Burns, Ellen Caples and Mable Ringling among them—met and decided they could help brighten up the town and the spirits of its citizens with flowers. They named themselves the Founders Circle and set as their goal "the creation of a more beautiful Sarasota, a more beautiful Florida."

The Founders Circle's first task was to perk up the downtown district by planting petunias and other flowers around the storefronts. The idea caught on, and other circles were formed—the Begonia and Tree Circles in 1928, the Indian Beach Circle in 1933. These circles became a federation called the Sarasota Garden Club and continued to grow as the value of their work became more apparent. The Palm Hibiscus Circles joined the Garden Club in the late 1930s. Today, 12 circles with about 400 members work to beautify Sarasota.

After they spruced up downtown, the Founders Circle moved on to other projects, including the Atlantic Coastline Railway Station, now demolished, that stood at the east end of Main Street. The railway station, built during the peak of the boom and a proud symbol of the "new Sarasota," had grown weed-strewn and dreary as the Depression deepened. Since it was the first place most newcomers saw, the circle decided to make it a positive first impression by weeding and planting flowers.

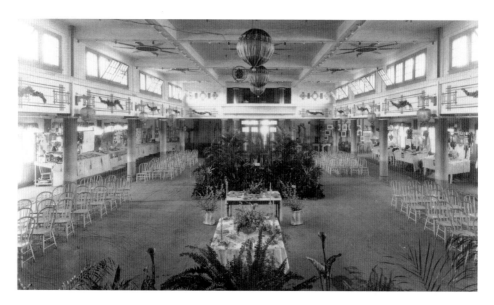

The Mira Mar Auditorium where the Second Annual Flower Show, produced by the Founders Circle of the Sarasota Garden Club, was held. *Courtesy Founders Circle.*

Other projects followed. In 1931, the first annual flower show was mounted. (The show continues, now sponsored by the entire Sarasota Garden Club, at the Garden Club headquarters, 1131 Boulevard of the Arts.) Also that year, Rosemary Cemetery was refurbished and a Junior Garden Club was started.

World War II came, and Garden Club members shifted their energy away from gardening and toward work for the war effort. But in 1947, they returned to their original mission and planted the beautiful Honor Park Memorial at the site of the present Garden Club headquarters behind the Sarasota Visitors Center. In those days, the property extended all the way to the bay, and the club planted majestic palms along winding white shell walkways leading to the water. The Honor Park Memorial was a fitting tribute to the men and women of Sarasota who had been killed in the war, but unfortunately a rough storm the following year washed most of it away.

The Founders Circle is as active today as ever. Each day on Arbor Day, it donates trees to Sarasota's public schools. Gardens have been planted at the Pines and the J.A. Floyd nursing homes. Members tend the urns of bougainvillea that line the courtyard of the Ringling Museum of Art. Along with the other circles, they also promote conservation measures, fight pollution and champion protection of the environment.

In 1984, their decades of work toward community beautification earned the Founders Circle acceptance into the prestigious Garden Club of America. It is one of only five clubs in Florida to be so honored.

The Depression years that drew the Sarasota Garden Club circles together are a distant memory. But its members labor on for the good of their community. As long-time member Lillian Burns put it, "We want people to be proud of Sarasota."

The Ritz and Florida Theaters

THOSE OF US WHO GREW up in Sarasota in the 1950s had a lot to choose from when it came to recreation. Even though we were a small town—27,000 people in 1955—we had the beaches, of course; fishing off the old Ringling Causeway or the City Pier; tourist attractions like the Circus Winter Quarters and Texas Jim Mitchell's animal farm, to name a few.

But the center of every kid's universe, especially on a Saturday afternoon, was the Ritz Theater. The Ritz was downtown, directly across from the Kress 5- and 10- cents store, and the line began to form in front of the ticket window before noon as car after car dropped off another load of kids.

For 10 cents, a typical bill might include *Utah*, with Roy Rogers and Trigger ("The Smartest Horse in the Movies"); the Bowery Boys in *Jungle Gents*; a *Jungle Raiders* serial; *Cartoon Carnival*; and previews of the next week's fare.

For those fortunate enough to have someone to hold hands with, the dimly lit balcony, especially on either side of the projection booth, was the location of choice. Everyone else sat next to the railing (at least for as long as it took to empty a popcorn box on someone's head) or downstairs. Most of us took our pleasure running back and forth to the snack bar, which served 10-cent dill pickles the size of the Hindenberg, JuJu Bees that could pull all your fillings out, Sugar Daddies guaranteed to last six weeks, and Nibs licorice chunks for those willing to turn their teeth a disgusting brown.

The Ritz was built in 1916, when it opened as the Virginian, named after the state of its builder. (The *Sarasota Herald* bragged that "this magnificent building would grace any city with five times our population.")

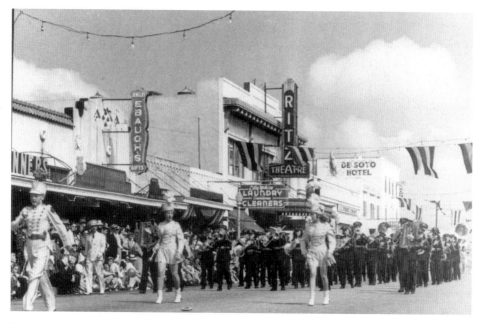

Sarasotans have always loved a parade; here, marching past the Ritz Theater in the 1940s is Sarasota High School's band. To the theater's right is J.C. Penney. *Courtesy Sarasota County Department of Historical Resources.*

In its early days, it presented stage shows as well as silent movies. In 1917, a Swedish actor impressed the audience with his impersonation of a female. According to the review, "It was a difficult matter to distinguish him from a woman, so well did he carry out the part." The Sarasota Minstrels also performed, as did vaudeville stars from the Keith and Orpheum circuits.

By the Roaring 20s, the Virginian had become the Sarasota Theater and reflected the times with such films as *The Silver Slave* with Irene Rich ("Mother Saves Daughter from Money-Mad Marriage by Stealing Her Love Away!") and *LOVE* with John Gilbert and Greta Garbo ("It'll Make You Gasp—It'll Make You Weep—It'll Make you Say, 'That's a PICTURE, What I Mean!'").

Two blocks away from the Ritz, and still with us today as the Sarasota Opera House, was the Florida Theater. Its strict ushers and plush decor of thick carpet, beamed ceilings, cut glass mirrors and ornate chandeliers did not encourage tossing items off the balcony or running full speed down the aisles. Parents and young adults frequented the Florida. A typical date would include a bite to eat at the Smack, a movie at the Florida and (one hoped) a drive out to a deserted beach to watch the submarine races.

Built in 1925 by A.B. Edwards, the city's first mayor, the theater hosted many renowned performers over the years—Will Rogers, Tom Mix, Tommy Dorsey and a newcomer called Elvis Presley. Ted Garrison, who was the projectionist in the 50s, remembers the mentalist who performed twice each morning for women

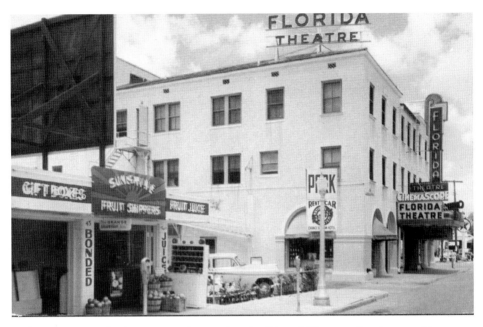

Lights, popcorn, action! Sarasotans thronged to the Edwards Theater when it opened in April 1926. Opening night entertainment included the Czecho-Slovakian National Band, the Theater Orchestra and a solo by Louise Philips, daughter of the theater's builder/owner A.B. Edwards, a Sarasota native prominent in local business circles. Roy A. Benjamin designed the Mediterranean Revival-style theater to accommodate silent movies, vaudeville and opera. The building also housed offices and bachelor apartments. It became the Florida Theater in 1936 and now, gloriously renovated, is the home of the Sarasota Opera. *Courtesy Joan Dunklin.*

This little scooter delivered the movie reels back and forth between the Ritz and Florida Theaters. *Courtesy Joan Dunklin.*

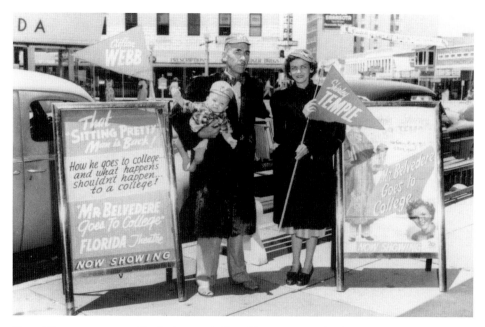

Harry Vincent, manager of both theaters, believed in promoting his films. This photo was taken in front of Lord's Arcade on Main Street in 1949. *Courtesy Joan Dunklin.*

only. He managed to parlay a three-day engagement into a month by dispensing answers to audience questions—some of them decidedly risqué for the times. (Question: "Should I tell my fiancé I wear falsies?" Answer: "You'd better; it's grounds for divorce if you don't.")

The Florida continued to show movies into the early 70s before it was closed down, to be reborn in the 80s as the home of the Sarasota Opera. The Ritz was demolished in the late 60s.

The Lido Casino

IF YOU WERE HERE IN the 1950s, those quiet predevelopment days, you must surely have fond memories of the Lido Casino.

White, bright and stately, the Art Deco-style casino was an impressive sight. For nearly three decades it was the hallmark of Sarasota's beaches, the perennial gathering place for us and our winter visitors. Tourist advertisements touted it (rightly) as Florida's most beautiful beach casino.

It's hard to believe that over 20 years have passed since this magnificent structure was demolished. It is harder yet to believe that Sarasota has grown so large that most of today's residents never knew this pleasant part of our past.

The casino was designed by local architect Ralph Twitchell (his plans were strikingly similar to drawings Albert Moore Saxe had proposed) as a Works Progress Administration project, using both federal and city monies.

Two days after Christmas, 1940, more than 1,000 invited guests attended the opening celebration of what was destined to be one of the loveliest and most widely used attractions in the city's history.

The casino was situated on two acres on Lido Key with 1,300 feet of beach frontage and was surrounded by royal palms, date palms and, of course, the whitest sand in the world. Each corner was accentuated by a tall white and brown tower. On the expansive second-floor terrace, four giant sea horses stared toward the azure Gulf of Mexico. Over the years they—and the four behind them—would serve as the backdrop for countless thousands of pictures. There was a regulation-size pool with two diving boards and a large wading pool for children to splash in and oldsters to soak their feet in, restaurants, shops, a snack

A bevy of beautiful Miss Florida hopefuls pose in front of the Lido Casino in 1967. This was the site of many beauty pageants. By the decade's end, the casino's deterioration prompted the president of the St. Armands Merchants Association to warn city commission candidates in *The News*, "And if you want to get elected, and if you want to get our vote, you'll do something about it." *Courtesy Sarasota County Department of Historical Resources.*

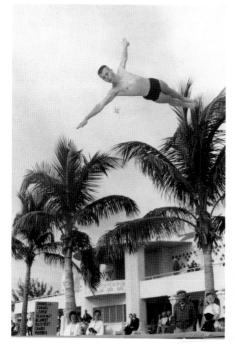

A single bound on a trampoline sends this youngster soaring into the air. The Lido Casino was the site of many gymnastic and swim meets. *Courtesy Sarasota County Department of Historical Resources.*

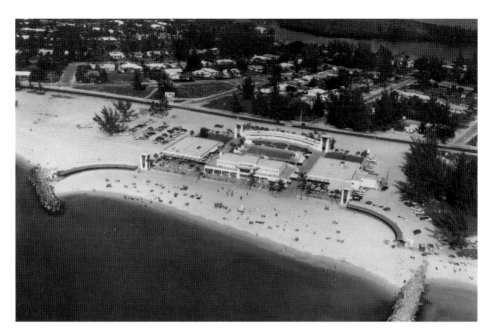

The Lido Casino proudly stands guard over the Gulf of Mexico in this 1969 photograph. The casino boasted a pool, restaurant, dressing rooms, shops and cabanas. The dog-bone groins jutting into the Gulf were built in 1959 in a $2,700 gamble by Sarasota City Commission to halt beach erosion. In the far background, Bird Key is under development; the small undeveloped islands are Coon and Otter Keys. Ben Franklin Drive is the road behind the casino. *Courtesy Sarasota County Department of Historical Resources.*

bar and a lounge with outside tables. Arching off each end, small cabanas with pastel awnings faced the Gulf.

The casino offered something for everyone and for every occasion. There was dancing in the Casa Marina Lounge ("On Lido Beach the nights are enchanting . . . It's time to listen to Rudy Bundy's music borne on the soft breezes of the Gulf of Mexico"). You could have a hamburger and Coke at the Low Tide Bar and Grill, or buy a dress at the Margaret Shop. The casino hosted beauty pageants, AAU swim meets, gymnastic events, school social functions, rallies and card games and was the place children begged their parents to take them on weekends.

Yet despite all that the Casino meant, it would not survive the 1960s. In 1969, to the consternation of many, the powers-that-be decided that instead of being remodeled, the casino would be demolished and replaced by a new Lido beach pavilion.

Today the pool is the only remnant of the glorious casino, a sad reminder for those who remember what once stood proudly around it. The destruction of the stately, romantic Lido Casino, the site of so many pleasurable hours, spelled the end of an era.

The Greatest Show on Earth

In the early '50s, Sarasota was a town of only 18,000, but we were accustomed to stopovers from the rich and famous. Indeed, we had our own colony of artists, writers, sportsmen, performers and socially prominent personages.

But in January of 1951, the town was abuzz. Cecil B. DeMille and a half-dozen of Hollywood's most popular stars—Charlton Heston, Betty Hutton, Gloria Grahame, Cornel Wilde, Dorothy Lamour and Lyle Bettger—were coming here not only for a visit but also to film a major motion picture that would highlight Sarasota's longstanding relationship with the circus.

The Greatest Show on Earth was to be a 153-minute spectacular in true DeMille tradition. The proverbial cast of thousands—it took over 3,000 to fill just one side of the Big Top—would be Sarasotans who would be paid 75 cents an hour—plus a million dollars worth of memories.

The idea for a production about the circus had intrigued DeMille since the 1920s. "The circus on tour is a rich American heritage, a modern odyssey of people and of the lives of people. Of spectators, too. I want to put that odyssey on a canvas of film, to capture the throb of the circus, its tragedy and humor and, if luck is with me, its universal soul," he said.

Local news of the grand event appeared first in the January 10 edition of the *Herald-Tribune*. An inconspicuous four-paragraph story announced, "DeMille Due to Film Movie." But thereafter, the writers and photographers had a field day publicizing everything the stars did during

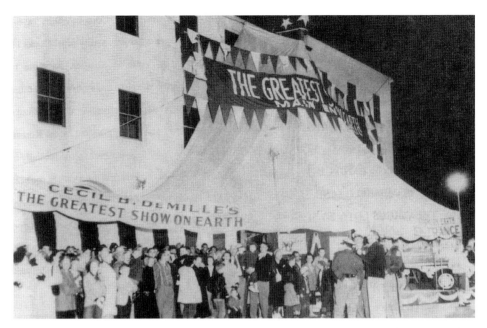

The Florida Theater is all decked out for the world premiere of The Greatest Show on Earth. The local filming of the Academy Award–winning movie brought international attention to Sarasota. Here, a crowd eagerly watches for the arrival of the stars. *Courtesy Joan Dunklin.*

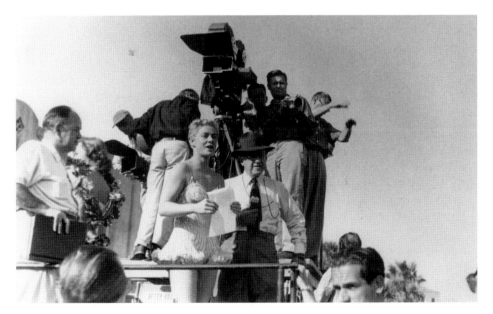

Director Cecil B. DeMille in hat, and star Betty Hutton address the audience just prior to filming the parade sequence. Thousands of Sarasotans were paid 75 cents an hour as extras. *Courtesy John McCarthy.*

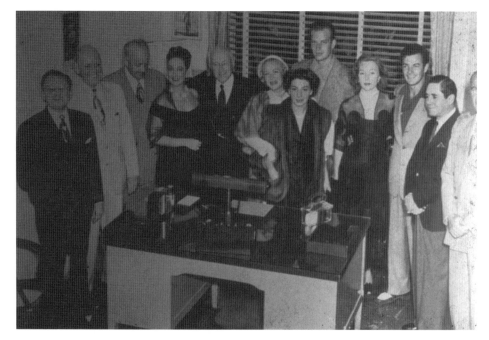

The stars of The Greatest Show on Earth gather in the office of Florida Theater Manager Harry Vincent before the world premiere. From left, Dorothy Lamour, Cecil B. DeMille, Betty Hutton and her mother, Charlton Heston, Gloria Grahame, Cornel Wilde and John Ringling North. Co-star Jimmy Stewart did his part of the filming in California, and did not come to Sarasota for the premiere. *Courtesy Joan Dunklin.*

their six weeks on location. *Herald-Tribune,* January 1, 1951: "BLOND BOMBSHELL [Betty Hutton] LANDS IN SARASOTA"; January 28, 1951: "BOMBSHELL (AND SHORTS) CHARMS THE CIRCUS LOT"; February 1, 1951 DOTTY [Dorothy Lamour] GETS OFF TRAIN AND CAPTURES SARASOTA."

The Main Street Reporter, Helen Griffith, described Hutton in her column of January 29, 1951, as "looking even more pulchritudinous in person than in pictures. And Cornel Wilde, w-e-l-l is he handsome and personality plus! Looks like quite a season." And on it went. Sarasota basked in Hollywood's glow and enjoyed every minute of it. It was certainly a refreshing change from the daily dose of bad news generated by the Korean War.

For their part, the stars seemed equally taken with Sarasota, marveling at the weather, the beauty of the town and the friendliness of the locals. As DeMille put it when he left, "The unexcelled cooperation of the city, the circus and all the people whose cordial relations made our work here a pleasant task are now a happy memory."

The production meant a lot to Sarasota. Besides the worldwide publicity, local businesses earned some of the $22,000 a day the movie cost to make,

and the townspeople were treated to six weeks of glitz, glamour, even an old-time circus parade through downtown.

The Greatest Show on Earth staged its world premiere at our own Florida Theater (now the Sarasota Opera House) and went on to become a box-office hit, ultimately winning Oscars for Best Picture and for Best Story.

By 1959, Ringling Brothers had fallen on hard times. The winter quarters, site of much of the filming and for so many years our top tourist attraction, were dilapidated and abandoned. Ultimately they would be demolished, and on that site Glen Oaks subdivision now stands. Sarasota was the Circus City no more. But for six weeks in the winter of 1951, the circus, Sarasota and *The Greatest Show on Earth* all meant the same thing.

The U.S.S. *Sarasota*

T HE U.S. NAVY NAMES ITS attack transport ships after counties, and by the end of World War II, Sarasota was proud of the ship that bore its name. The attack transport U.S.S. *Sarasota* was commissioned on August 16, 1944, and after a brief shakedown cruise headed for the fighting. She participated in several invasions, survived a suicide attack, twice rescued other ships at sea and as part of the Magic Carpet Fleet transported the famous "Iwo Jima Flag Raisers," the Second Marine Division, back home.

By the end of the war, the ship and her crew had received numerous citations and commendations, including a Silver Star, four Bronze Stars, seven letters of commendation, 13 Purple Hearts and three Battle Stars. Not one of her crew had been killed.

The ship was reactivated for the Korean conflict, and in 1951, Sarasotans decided to meet their namesake in person. They invited the U.S.S. *Sarasota* to help the city celebrate Independence Day.

The ship arrived early on Saturday morning. Because of her nearly 10,000-ton displacement, she had to anchor two miles off Lido Beach. Local dignitaries met with Captain Mitchell and for the next three days, the red carpet was out.

Among the festivities were a fish fry at Bayfront Park; dinner and dancing (for the officers at the Sarasota Yacht Club, for the enlisted men at the Lido Casino); greetings by every politician in town; tours of the city's attractions and transportation to Sunday services. The town presented one radio-phonograph to the officers, another to the crew and the Town Key to the captain. As the *Sarasota Herald* headlined it, "CITY CAPTURED BY *U.S.S. SARASOTA*."

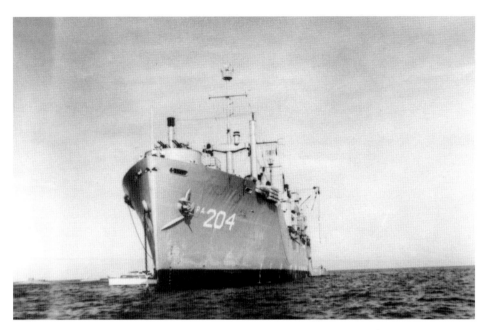

The World War II attack transport ship, U.S.S. *Sarasota*, as it visits its namesake county in 1951 and prepares to capture the hearts of local residents. *Courtesy Joe Steinmetz*.

Thousands turned out to watch the mock invasion of Lido Beach staged in 1951 by the visiting sailors of the U.S.S. *Sarasota*. Nearly 9,000 people were ferried back and forth on the ship's landing craft to tour the huge vessel. The visit was so successful, it was repeated the next year. *Courtesy Joe Steinmetz*.

In return, the crew staged a mock invasion of Lido Beach with narrative over loudspeakers. They also ferried thousands of excited townspeople back and forth between City Pier and the ship on its LCVP landing craft, and an inscribed ship's bell was presented to the town by an appreciative captain. In his farewell speech, Captain Mitchell said, "We've had a wonderful time and will long remember this visit to Sarasota. Most of us look forward to a return here someday." (That day wasn't too far off; the visit had been so successful that the ship came back the very next Independence Day.)

Locals started a movement to have an exquisitely perfect, $250,000 model of the ship brought to Sarasota from the Naval Museum in Washington, D.C. In July 1989, thanks to the efforts of Jack Hoffman and former crew member John Shilalie, an exact model of the ship was brought to Sarasota and placed on display in the lobby of the county administration building.

The Winter Quarters

I F YOU DRIVE TO THE north end of Beneva Road, to the Glen Oaks subdivision, you will find a historical marker that is both informative and sad. Informative, because without it there would be no way of knowing you were near the entrance to what was once one of the most popular attractions in the state. Sad, because it seems there should be something more impressive than a green marker with a few dozen words to mark the spot that was both the home of *The Greatest Show on Earth* and the reason Sarasota was known around the world as the Circus City.

The headquarters was here from 1927 to 1959, when the property was sold to a developer and the headquarters moved south to Venice. Those of us who lived here during that era will never forget the excitement that was generated each November when the long silver trains pulled into town, bringing back home the stars of the circus. It was front-page news when the aerialists, acrobats, wire walkers, showgirls, clowns, midgets and roustabouts rejoined their friends in the community and re-infused Sarasota with color and excitement. The circus children returned to school and held us mesmerized with tales of life on the tour. Often they, too, were performers, the next generation of circus legends who would follow in the footsteps of their parents.

There were bits and pieces of the circus scattered throughout the city, but its focal point was the elaborate Winter Quarters, a nearly 200-acre mini-city that had everything necessary to care for its people, animals, props and equipment—a maze of dormitories, shops, offices, cages, stables, buildings, trains and trucks.

Even at home the circus never rested. One season was over but the next one had to be prepared. And when wide-eyed visitors drove through the main gate, they

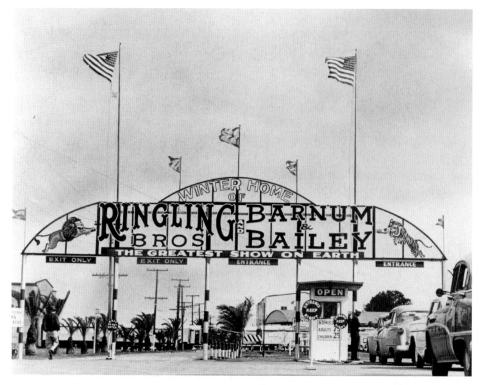

Step right up to The Greatest Show on Earth's winter quarters, which, until it left Sarasota for nearby Venice in 1959, stretched across east Sarasota for 200 acres. Shown here are a few of the 90 circus trains that carried performers, animals and equipment to 150 towns all across America. Each year, Monsignor Ellslander, of St. Martha's Church, would bless the circus trains before they departed for their tour.
Courtesy Sarasota County Department of Historical Resources.

were greeted by a bustle of activity and the exotic sights, smells and sounds of the circus everywhere.

The first stop on the tour was always the three-ring outdoor amphitheater known as "Little Madison Square Garden." Every Sunday the various troupes staged the shows they had been rehearsing all week and the clowns delighted visitors with their makeup and gags.

Another area housed dozens of different animals—pacing lions and tigers, soft-eyed camels and llamas, bears and giraffes, hippos and rhinos in pools, monkeys scrambling around their cages, horses and zebras in the stables. There was even a nursery where baby elephants were tutored in the proper behavior under the Big Top.

Less glamorous but no less important were the workers who were responsible for repairing, repainting and refurbishing all the props, riggings, wagons, seats, canvas, costumes, poles, stakes, ropes and the 90 railroad cars that took the circus around the country. Their work went on night and day.

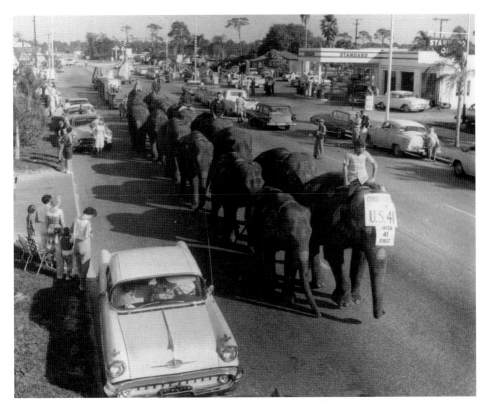

Bringing up the rear, the elephant walk. *Courtesy Sarasota County Department of Historical Resources.*

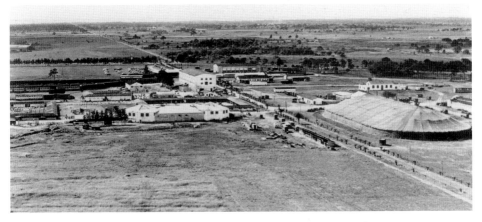

The Big Top, was truly cavernous. Measuring 544 by 244 feet, it required a canvas crew of 225 men plus numerous eager school children to unravel it and prepare it for hoisting. It was supported by four main Oregon fir poles that stood 60 feet tall, and 122 side poles spaced around the perimeter. The Big Top was folded for the last time in Pittsburgh in July 1956, marking the end of an era of the tented circus. *Courtesy Max Frimberger.*

Ted the Giant and Harry Doll were two of the circus performers you'd likely meet while visiting the winter quarters. *Courtesy Max Frimberger.*

By March, all was ready. Monsignor Ellslander and his altar boys from St. Martha's Church blessed the train, and thousands of well-wishers waved as the circus departed for another season of entertaining children of all ages around the country.

The Smack

It's one of Sarasota's most endearing symbols of the way we were: the Smack Restaurant.

In its day, this unpretentious drive-in managed to be popular with just about everyone. Teenagers cruised it a la *American Graffiti*; businessmen ate lunch there; singles met, fed nickels into the jukebox and moved on; families came for the prices (in 1955, a half fried chicken with fries, slaw and rolls cost $1.25, and the giant Smackburger was 85¢); preteens looked forward to the day when they, too, could come to Smack's—without their parents.

W.L. "Mack" McDonald opened the Smack—a contraction created from the name of his best friend Sam and his own nickname—in 1934, when he bought out the Ducky Wucky hamburger stand on the corner of Main and Pine Streets for $350.

When Mack was over 80, he still clearly remembered the days when fountain drinks were called "dopes"—as in "gimme four dopes, two with a squirt of cherry"—and he remembers Sunday afternoons when his parking lot was filled with customers listening to the Guy Lombardo Orchestra piped over a loudspeaker he had attached to a tree limb.

In 1937, he bought the property on the corner of Main and Osprey (where SunTrust stands today) for $15,000. For a thousand dollars more, a carpenter friend built the Smack that most of us remember.

In those days, Main Street was Highway 41, and every bus and car going to and coming from Miami drove by Smack's at about 25 miles per hour. Many pulled in to load up on burgers, fries and ice cream. But what really made the

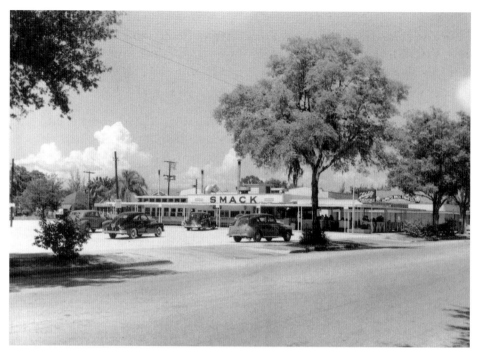

Everybody met at the Smack, at the corner of Osprey Avenue and Main Street (then Highway 41), where SunTrust stands today. *Courtesy Norton's Camera.*

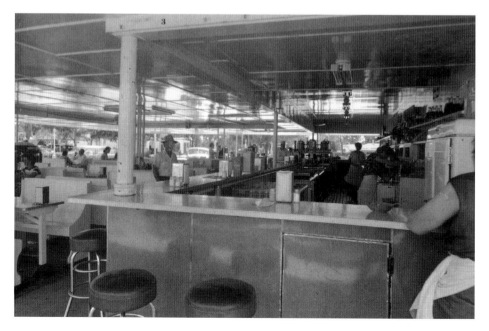

In 1951, the Smack was Borden Ice Cream's number-one account in Florida. *Courtesy John McCarthy.*

business skyrocket were the teenagers. "We did everything we could to please the kids," McDonald remembers. "Whenever Sarasota High had an athletic event, busloads full of teenagers came." (And during the heyday of the Sarasota-Manatee football rivalry, some of the most exciting action took place in the parking lot of Smack's.)

During the war years, on Friday nights men from both the Sarasota and Venice air bases were dropped off and picked back up at the Smack. The bars closed at midnight in those days and bar hoppers came in for a late-night snack on their way home.

The restaurant's busiest year was 1951. The menu had expanded to include 12 dinner plats, 16 types of sandwiches, various salads, soft drinks and beer. The Smack was Borden Ice Cream's number-one account in the state.

But by 1957, a rowdier bunch of teenagers had started coming, bringing their own beer on the lot and business also slipped after a two-way radio ordering system replaced the friendly curb girls. McDonald sold out. The $350 he had paid for Ducky Wucky's had grown to a business that brought $300,000; the simple operation with one fountain man and one curb girl now included 93 employees.

The business lasted a year or two under the new ownership, then closed down. It sat vacant, there was a fire, and finally it made way for Coast Federal. (Today it is the site of SunTrust.)

But McDonald cheerfully recalled for me the way it was: "In the old days, everybody went to the Smack."

The Plaza Restaurant

THE PLAZA RESTAURANT WAS ON First Street, a short walk from Five Points and the old Palmer Bank. The Spanish restaurant was in a pleasant white stucco building, marked only by a small neon sign that belied its importance in the community. For during the years when downtown was the hub of Sarasota's social, political and business life, the Plaza was its focal point.

It was the place where bankers and developers put deals together. Mike Clarke, a local developer in the early 50s, remembered that "all the people and information necessary to complete a transaction would be gathered at the Plaza at lunch." It was also where lawyers, judges and politicians discussed events of the day; where our colony of writers and artists—MacKinlay Kantor, John D. MacDonald, Syd Solomon, Thornton Utz, Joe Steinmetz and others—met for the local version of New York's Algonquin roundtable; where winter residents and visiting celebrities came to connect with the community; and where locals celebrated weddings, anniversaries, graduations and other rites of passage. On any given day, the Who's Who of Sarasota could be found there.

Not coincidentally, it served the finest food in Sarasota and won praise from *Holiday* magazine and Duncan Hines. When "Sarasota's oldest restaurant" opened, Herbert Hoover was president, and it remained open through Richard Nixon's administration.

Yet it would be difficult to find a less opportune time to begin a successful business than in 1928, when the Plaza served its first meal. The bottom had recently dropped out of local real estate, and in another year the entire nation would be engulfed in the Great Depression. Nonetheless, partners Benny Alvarez, who took

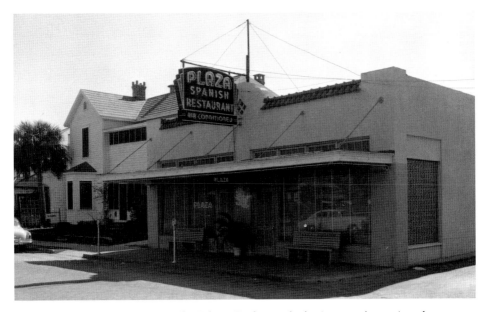

The Plaza, on First Street next to the Palmer Bank, was the businessman's meeting place long before power lunches became de rigueur. The building, much expanded, later housed Merlin's Restaurant. *Courtesy Joe Steinmetz*.

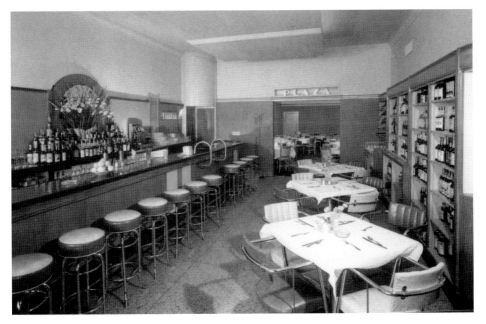

A view of the Plaza's bar, where Flash, the bartender, could remember the preferred drink of every regular customer. *Courtesy Joe Steinmetz*.

care of the bar, C.G. "Raymond" Fernandez, the cook, and Randy Hagerman, who came into the business in the 1930s, charted a course that would take the Plaza through 35 years in five separate decades, and give it enough momentum to last for another eight years after it was sold.

Personal service was the key to the restaurant's success. Former patron Mike Clarke recalled that the bartender known as "Flash" (Joe Mitchell) could remember the preferred drink of every customer, and would have it mixed, poured and on the bar by the time they got to their favorite seat.

Stories of the Plaza and its colorful and influential patrons abound. Russell Thomas, Sarasota County judge during the restaurant's heyday, said that when Congressman James Haley was in town, the Plaza was his second office. Certain tables were reserved for regulars; for example, prominent lawyer Art Bell held court with other local attorneys at a table dubbed "King Arthur's Table."

A legendary poker game ran for years in the back room. Benny Alvarez said it was started by a dishwasher named Mike in the 1930s when Raymond Fernandez was on a visit to Spain. Soon it grew into a local tradition, and most of the town's notables played a hand at one time or another. The Plaza itself never made any money from the game, said Fernandez, just goodwill.

It seems longer, somehow, but only 25 years have passed since the Plaza closed. Most of its principal players have retired or passed away. But during that wonderful era before the relaxed town of Sarasota evolved into our speeded-up city, they all came together at the Plaza Spanish Restaurant. "Those were fine days," Alvarez told me. "Everything was like a holiday."

The War Years

IT WAS WORLD WAR II and if you tuned into WSPB, "The Biggest Show in Town," you'd hear love songs like "Sentimental Journey" and "Serenade in Blue." Downtown, the Ritz and Florida theaters featured lightly veiled propaganda films such as *Back to Bataan* and *Sands of Iwo Jima*, while Movietone newsreels showed the real action. Even Bugs Bunny easily made saps of Tojo, Mussolini and Hitler.

It was a time to rally around the flag, to fight and to sacrifice. Everyone had a job to do, a role to play in the fight against the Axis.

Families who lost a loved one in battle hung a gold star in the living room window. Victory Gardens were planted in backyards, and cars were driven on bald tires and nearly empty gas tanks. Some 2,700 Sarasotans signed up for A-ration books, which allowed them four gallons of gas per week. Firestone did not always have tires to sell; the company advertised a special black paint to make the old ones look like new.

Sarasota High seniors were joining up before graduation and younger kids could buy Krak-A-Jap toy machine guns for $1.29. On lower Main Street, D.C.'s Manhattan Club lounge ("Where Fun Begins") featured The Bar of Defense and served 50-cent cocktails with names like Victory V, Air Raid and Depth Bomb. Wednesday was Bonds for Bombs Night—"The more bonds you buy, the more planes we'll fly."

There were flashes of real excitement. Charles Morris was a youngster during the war and recalls when an air-base training plane crashed in front of the entrance of Ca' d'Zan. He rode his bicycle over and found parts of the plane scattered about. He also remembers hearing the machine guns fire off Longboat Key at targets that were pulled behind planes flying over the Gulf.

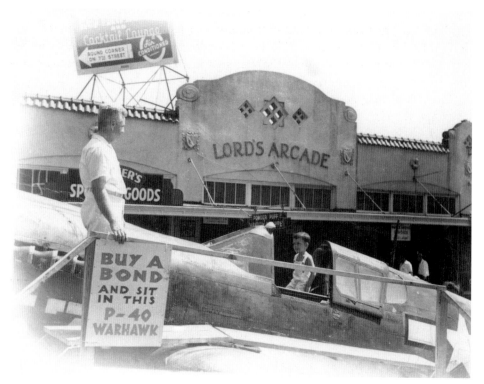

Bond drives were an important part of the war effort. This P-40 Warhawk is parked at Five
Points. To the left of Lord's Arcade is Tuckers Sporting Goods; the sign points the way
to one of Sarasota's most popular restaurants, the "air-conditioned" Plaza Restaurant. The
young, would-be pilot is Dick Angers, now owner of Angers Auto World.
Courtesy Dick Angers.

But the most obvious change to Sarasota's 11,000 residents was the influx of
uniformed servicemen. With Carlstrom Field in Arcadia, Drew Field in Tampa,
and Army AirCorps training bases both here and in Venice, we looked less like
the Circus City and more like Fort Sarasota. The Sarasota base housed up to
3,000 men, and they usually spent their leaves mingling with the townspeople. On
Friday, Rex Kerr's *Air Field Eagle* newspaper kept the boys abreast of local events
and social functions. They were invited to "Bowl at the Bowladrome for Vim,
Vigor, Vitality and Victory." Merchants advertised discounts to men in the armed
forces, draft beer sold for a dime, and for those who couldn't make it back to the
base, the American Legion Coliseum (ironically, it would become the Heidelberg
Castle) offered free beds.

The *Sarasota Herald* was filled with accounts of the war's progress and reported
on the home front's efforts: "Local FBI raid nets taboo items in possession of
aliens"; "Sarasotans buy $304,909 worth of bonds in March to set new mark";
"Sarasota High class of '43 graduates 116—seventeen in uniform"; "Several
ration books snitched."

Blackout practices were held by the Sarasota County Defense Council. One long blast meant 10 minutes to blackout. Two long blasts—all lights out, cars pull up to curb and extinguish lights. Early in the war, citizens were advised to arrange one room so that no interior lighting could be seen from outside.

On Lido Beach, neon lighting was banned to prevent silhouetting navy ships in the Gulf. Revelers drove back and forth to the key using their parking lights.

When the war ended, thousands of soldiers had spent time in this beautiful resort town they would otherwise never have seen. They took home with them memories of the nightclubs, beautiful beaches, balmy weather and friendly locals. Quite a few would return to make this their home. But 67 of Sarasota's sons and one of her daughters had lost their lives in the war and would not return.

The Sara de Sota Pageant

IT WAS THE PERENNIAL HIGHLIGHT of the tourist season, a delightful blend of circus fun, Mardi Gras pageantry and beauty-contest glamour, mixed with the folksiness of a county fair.

During its heyday—from the 30s through the 50s—the Sara de Sota pageant was an annual affair that drew merrymakers from all over the nation to help us celebrate our Spanish heritage—both real and imagined.

The ostensible reason for all the hoopla was the legend of Sara DeSoto, daughter of explorer Hernando DeSoto, and Chichi-Okobee, "the fleet and strong Seminole," who yearned for her with unrequited love. (Pageant organizers kept the proper spelling of Sara DeSoto, but changed the festival to de Sota, to reflect the city of Sarasota.) As the story goes, having beheld the beautiful maiden, Chichi surrendered himself to DeSoto "that he might occasionally feast his lustrous eyes upon the orbs of this princess of the house of DeSoto." But Chichi soon fell ill with Everglades fever. He was about to die when Sara begged her father to let her nurse the young Indian chief. "Her ministrations wrought a miracle," and soon he mended. But alas, now the lovely Sara sickened with the fever, and soon she died. A distraught Chichi gained DeSoto's permission to bury Sara in the most beautiful spot in the world, a bay that would forever be known as Sarasota Bay. (Chichi and a hundred braves, in what the legend termed "a wonderful thing," drowned themselves so they could guard her resting place.)

The tragic love story was first enacted in 1916, when Sarasota was barely more than a village. Genevieve Higel, daughter of early Siesta Key developer Harry Higel, played Sara, and J.B. Chapline, whose brother George wrote the "legend,"

played the lustrous-eyed Chichi. The premiere event drew several thousand out-of-towners, making it a rousing success. But thereafter it was scheduled only sporadically, until 1935 when the Junior Chamber of Commerce took it over. Through their guidance, the event achieved national recognition and rivaled any festival in the South.

After World War II, the pageant became even more popular. By 1948, the sleepy city of Sarasota, population 15,000, expected over 75,000 to show up for the festival's spectacular Grand Parade.

Art Bell, Jaycee president that year, directed one of the most memorable pageants ever. The eight-day affair began on Sunday morning with a sailing regatta on Sarasota Bay, followed by a golf tournament at Bobby Jones. On Monday the pace picked up with the opening of the annual county fair, a huge fireworks display on Golden Gate Point and a boxing match at the American Legion Coliseum. The legend was acted out that night by the Players, and was broadcast over radio station WSPB.

The next night a king and queen were chosen at the Municipal Auditorium, lavishly decorated for the Coronation Ball. The royal couple paraded between the raised sabers of uniformed cadets from Kentucky Military Institute, which at that time had a school in Venice. Wednesday's main event was a beauty contest at the Lido Casino, followed that night by another fireworks display. On Thursday and

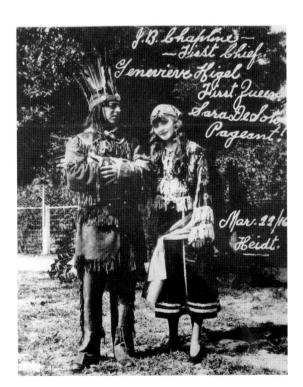

In 1916, Genevieve Higel and J.B. Chapline took the lead roles of Sara DeSoto and Chichi-Okobee, "the fleet and strong Seminole," in Sarasota's first Sara de Sota pageant. *Sarasota County Department of Historical Resources.*

Friday, there were a fashion show, lawn bowling, a shuffleboard tournament and street dancing on lower Main Street. The music was provided by Frank Evans and the Solid Six, and a jitterbug contest was held. (To assist the swingers, 300 pounds of grits were sprinkled on the street.)

Saturday was the big day. In the afternoon, children bashfully marched as storybook characters, and the evening's Grand Parade was the most exciting event of the year, bringing out the largest crown in Sarasota's history. Elbow to elbow along the entire route, thrilled spectators were treated to an eye-filling array of ornate floats with waving beauties, snappy marching bands and drill teams and majorettes. But the pièce de résistance was the Ringling Brothers and Barnum & Bailey Circus, which showcased its performers, clowns, showgirls and exotic animals. It was the circus that validated the Jaycees' claim that the parade was unequaled anywhere else in the world.

The pageant continued to reach such grand heights until 1957. The next year, the Jaycees voted to celebrate our Scotish heritage, so kilts and glengarries replaced pantaloons and veils, and the legend of Sara and Chichi made way for the Coming of the Scots. But the next time you're near the passes where the Gulf meets the bay, look at the whitecaps. Legend has it that they are the warriors of Okobee, protecting the resting place of Sara DeSoto.

Bird Key

THE ARRIVAL OF THE ARVIDA Corporation in 1959 was a watershed for Sarasota. Just as the completion of the Mira Mar Hotel on Palm Avenue in the early 20s had signaled our emergence as a fashionable resort, the announcement that Arvida planned to develop Bird Key and John Ringling's other Sarasota properties (bought for a reported $13.5 million) indicated that Sarasota's days of being a small, quiet town were numbered.

In the 20s, Andrew McAnsh, the developer of the Mira Mar, had been welcomed to town by a brass band and a wildly enthusiastic crowd who knew how important his world-class hotel was to Sarasota's future. Pictured frequently in the press in a vested suit and straw hat, he was labeled a "town builder" and pronounced, "I am sanguine that Sarasota has a great destiny."

Three decades later, Arvida's reception was equally grand, its promises and hopes for Sarasota's future just as bright. And while no brass band marched the company's general manager, John Weir, through town, he was given a red-carpet welcome. In a full-page "Salute to Sarasota" advertisement, Arvida declared "It's a rare city here or abroad that has an iota of the charm of Sarasota. You'll find us good neighbors."

Over 1,000 eager real-estate brokers, salesmen and citizens packed the Civic Auditorium to hear Arvida's pitch, see the slide show and listen by telephone hook-up to "Today" show host Dave Garroway. By evening's end, the overwhelming consensus was that Sarasota and Arvida would be good for each other.

The first phase in the company's grandiose development program was to be Bird Key, and its promotion surpassed anything ever seen in Sarasota. Full-page

ads, slick brochures, television and radio spots, articles in *Life, Time, Sports Illustrated* and other national publications touted Sarasota throughout the country. And to keep the local momentum going, Arvida devised a contest, offering a 27-foot Chris-Craft Constellation cabin cruiser or a new Lincoln Continental to the person who sold the most Bird Key lots.

The object of all this promotion had originally been the spectacular domain of Thomas Worcester. He added to the 14-acre isle in 1912 by dredging up 30,000 cubic yards of sand, planting trees and tropical foliage and building New Edzell castle, a $100,000 showplace named after the ancestral Scottish estate of his wife. In a letter to Worcester, she wrote of Bird Key: "This is what I want for my old age . . . Oh! Words cannot paint the scene—imagination cannot conceive of such grandeur." It was to be their retirement paradise, but Mrs. Worcester died before its completion.

In the early 1920s, John Ringling purchased the property from Mrs. Mary Elizabeth Pickett and linked it to the mainland with the Ringling Causeway. When Ringling died in 1936, he bequeathed it to his only sister, Ida Ringling North, who lived there until she died in 1950.

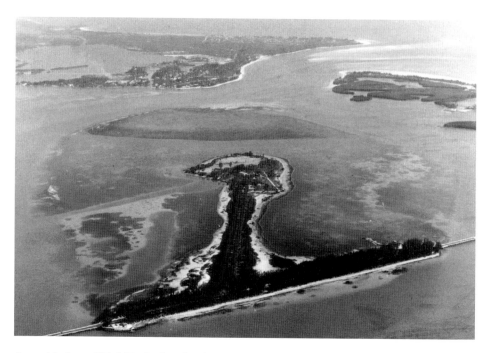

An aerial view of Bird Key before the dredging that would transform it into a 300-acre luxury subdivision. The island's only dwelling, a $100,000 home built in 1912 by Thomas Worcester for his wife, can be seen among the trees. She died before its completion, but years later prominent local resident Ralph Caples proposed using the home as a retreat for his friend, President Warren G. Harding. *Courtesy Sarasota County Department of Historical Resources.*

Bird Key Development Corporation, whose president was Ida's son, circus head John Ringling North, bought the property in 1951 with the intention of expanding it to almost 300 acres. Their plan for luxury home sites was similar to the one Arvida would offer less than a decade later, but the Ringling consortium received a less than enthusiastic reception. During a particularly acrimonious public hearing, State Representative James Haley asked the Ringling group's attorney, "Why don't you go back to New York and run your own business?" A.B. Edwards, one of Sarasota's most revered citizens, feared that the development would hurt the bay. He warned, "When you interfere with the channels, bars, currents and waterways, you're liable to have trouble." After several modifications and a number of hearings, votes and court actions, the Ringling proposal was shelved.

However, it had laid the groundwork; so nine years later, when 90-year-old Arthur Vining Davis, chairman of Arvida, came to town to steer his company's proposal through, the powers-that-be were impressed. The proposal was swiftly accepted.

The approval plat included 511 home sites—291 were on the water—with the then-futuristic concept of underground utilities, a $250,000 yacht club of Colonial Bahamian design and the most attractive feature of all, "the sheer beauty of Bird Key's tropical vista."

On October 15, 1960, after one year's work, the project was completed. Lots were priced from $9,000 to $32,000 and sold quickly. Arvida then turned its attention to the 1,000 acres it owned on Longboat Key. Under the umbrella of the Longboat Key Club, it started off with a beachfront condominium, Longboat Key Towers, and followed with Seaplace and Bay Isles. Other projects followed, including in 1982, the world-class Inn on the Beach. Some 40 years after it began, Arvida has developed most of its Sarasota holdings; the company is still marketing a number of properties, but earlier this year it sold the Inn on the Beach and resort operations. In its three decades here, Arvida has done much to shape and define the Sarasota that is known all over the world today for its spectacular homes and beautiful recreational facilities.

Bits and Pieces

In the first half of the last century, the Gulf of Mexico and Sarasota Bay literally teemed with fish. Proud anglers displayed their catches, like this tarpon, in front of their hotels and in front of Tuckers Sporting Goods. Tuckers, whose motto was "Tuckers Tackle Takes 'Em," opened in 1927, moved to the corner of State Street and Pineapple Avenue in 1953 and for many years was a mainstay for sporting equipment. *Courtesy Norton's Camera.*

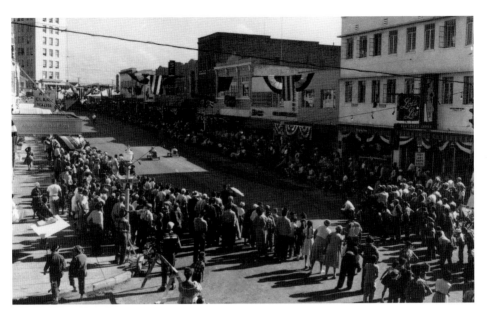

An exciting part of the yearly Sara de Sota celebration was the Soap Box Derby, shown here in the early 1950s. Fifty racers started from a ski ramp and sped down lower Main Street to Palm Avenue, achieving speeds of up to 24 miles per hour in their homemade automobiles. The winner advanced to the National Soap Box Derby in Akron, Ohio, where he could win a scholarship to the University of Tampa. *Courtesy Sarasota County Department of Historical Resources.*

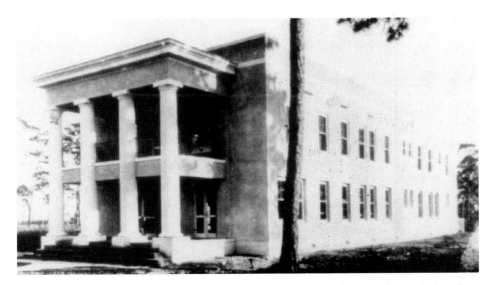

Sarasota Memorial Hospital when it opened with 32 beds, 15 employees and a medical staff of 13 doctors on November 2, 1925. It was built with proceeds of a fund-raising campaign by the Sarasota Welfare Association, led by Mrs. George B. Prime. A $175,000 annex was completed in 1927. Sarasota Memorial has continued to grow with the population, and today is one of Florida's largest hospitals. *Courtesy Christie Bussjaeger.*

Roger V. Flory, at one time reportedly Sarasota's only registered Republican, campaigns on Main Street for presidential hopeful Wendell Willkie in Willkie's 1940 race against Franklin Roosevelt. Flory, a Chicagoan, first visited Sarasota in 1925 and returned to found a real estate company that still bears his name. He also edited the very popular *Sarasota Visitors Guide* for many years. *Courtesy Norton's Camera.*

Sarasota's fire department on Third Street in the 1930s. The building was saved from destruction in the late 1980s when it became The Swan and The Frog antique shop. From left, Chief Knowles and firemen Hood, Cowsert, Davis, Walker and Gaskill. *Courtesy Norton's Camera.*

Ross E. Boyer was first elected sheriff of Sarasota County in 1952, running on the campaign slogan, "No friends to reward, no enemies to punish." He was re-elected in 1956, 1960, 1964 and 1968, resigning from office his last term because of poor health. *Courtesy Sheriff's Deputy Bob Snell.*

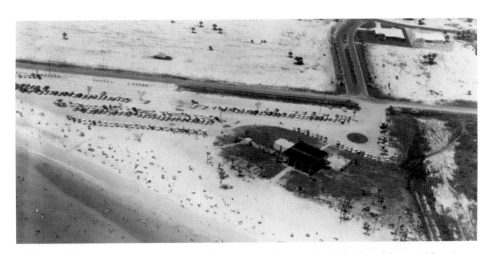

After World War II, Siesta Key's population grew to the extent that the need for a public beach became evident. A bond election authorized $250,000 to purchase a suitable site. The Harry Gregg tract, with 1,100 feet of beach frontage, was the first choice. After condemnation proceedings (Gregg had earlier offered a 99-year lease), the parcel was bought for $80,000. Subsequent land purchases gave the county 40 acres of public beach with 2,400 feet of beach frontage. The pavilion, designed by Sarasota School of Architecture architect Tim Seibert, opened in August 1959.
Courtesy Sarasota County Department of Historical Resources.

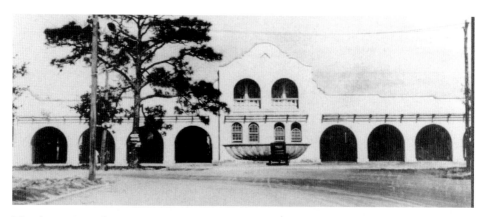

The elegant Spanish Mission-style Atlantic Coastline railway station opened at the east end of Main Street in October 1925. Such trains as The Everglades, Dixie Flyer and Floridian brought Sarasota-bound passengers from Northern cities. The station was built on this site at the suggestion of city planner John Nolen, who recommended that buildings of architectural merit be used at the termination of major vistas. When it opened, the railway station was hailed as "a tribute to the certainty of Sarasota's future." After the trains stopped running nearly 50 years later, Brewmaster's Steak House opened in the building. It was demolished in 1987. Note that the street is made of brick paving overlaid with asphalt. *Courtesy Norton's Camera.*

Tom Bell and his brother, John, came to Sarasota from Sanford in 1926. Their expertise in celery production would soon make Sarasota one of the world's largest celery-growing areas. The brothers built and operated the Palmer Farm Growers Cooperative and Packing House on Packinghouse Road in east Sarasota. Through their efforts, agriculture was once the leading industry in town. *Courtesy Tom Bell.*

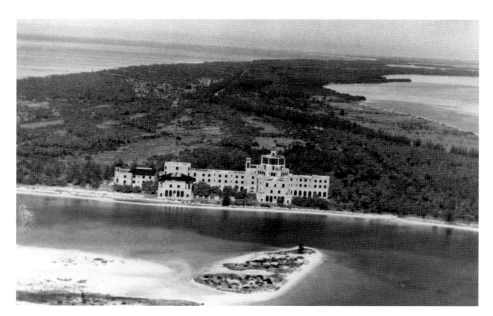

John Ringling sank a fortune into building his Ritz Carlton Hotel on the southern tip of Longboat Key in the 1920s, but despite an infusion of cash from local investors, he couldn't complete it before Florida's real estate bust and the subsequent stock market crash in 1929. The half-finished shell stood empty until January 1964, when it was demolished. *Courtesy Pete Esthus.*

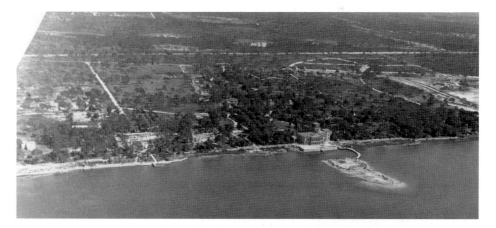

Ca' d'Zan, "House of John," as it looked in late 1925 shortly before its completion. Venice, Italy, was John and Mable Ringling's favorite European city. In planning their magnificent new home Mable drew inspiration from Venice's Doges Palace and a tower designed by friend Stanford White for the original Madison Square Garden in New York. The mansion was willed to the state of Florida when Ringling died in 1936. This photograph shows the dredged island created in Sarasota Bay to off load building materials during the railroad embargo of 1926. The island and a gondola that Mrs. Ringling had docked near it were washed away in the hurricane of 1926.
Courtesy Sarasota County Department of Historical Resources.

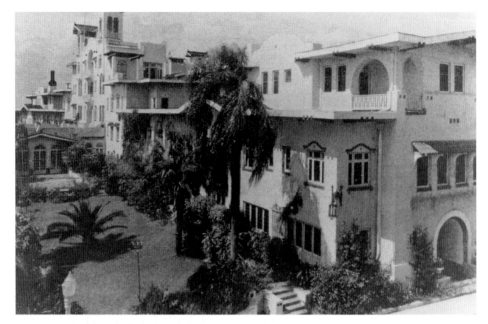

"Sarasota's Palatial Hostelry," the Mira Mar Hotel, was the first boom-time hotel to cater to the city's rich and famous tourists. Newcomer Andrew McAnsh built the adjoining Mira Mar Apartments in a record 60 days at the end of 1922, and then built the hotel and nearby auditorium, which opened in 1924. When the auditorium was torn down in 1955 for a parking lot A.B. Edwards remembered for *The News* that from 1925 to 1928 a gambling casino was run on the upper floor by casino operators Conrad and Locke of Chicago. Edwards said the casino was only for well-to-do visitors; locals weren't allowed past the guarded door. *Courtesy Sarasota County Department of Historical Resources.*

Baseball fever first struck Sarasota in 1924, when the New York Giants practiced here for three seasons. In 1933, the Boston Red Sox made Payne Park their spring training headquarters. Among the pros who populated the city for a month or two each spring was legendary Ted Williams. Williams won six batting titles—one of them at the age of 40—and in 1941 was the last man to break the .400 mark. Old-timers remember him indulging heartily in his favorite hobby, fishing. *Courtesy Sarasota County Department of Historical Resources.*

The Red Sox left town in 1958, and the Chicago White Sox began training here in 1960. Here, then White Sox owner Bill Veeck is fanned, literally. *Courtesy Sarasota County Department of Historical Resources.*

Writers and artists of national repute have long called Sarasota home. Shown here is MacKinlay Kantor, who, along with John D. MacDonald were two of the most notable. Kantor moved to Siesta Key in 1936, where he penned his Pulitzer Prize-winning novel, *Andersonville*, 20 years later. He died in Sarasota in 1977. *Courtesy Sarasota County Department of Historical Resources.*

Another famous writer who dropped by: mystery writer Mickey Spillane promoting his novel, *The Deep*, poolside in 1961. *Courtesy Sarasota County Department of Historical Resources.*

The excitement of Sarasota's circus heritage spilled out into its streets. Here, Dixie Graves, an Aquabelle at Sarasota's Sunshine Springs and Gardens, Christmas shops along Main Street with Tigre, the world's only water-skiing ocelot. Sunshine Springs and Gardens was developed in 1955 by brothers Leonard and Charles Tanner in conjunction with the Lake Sarasota subdivision. They dreamed of a tourist attraction twice as big as Cypress Gardens, drawing 50,000 sight-seers a year. Despite Tigre and a 1,200-pound water-skiing elephant named Jumbo, it closed a few years later. *Courtesy Mrs. J.C. Cash and Sam Montgomery.*

A portrait of the world-famous Emmett Kelley, a longtime Sarasota resident who entertained circus audiences as Weary Willie for nearly six decades. Kelley died at the age of 80 in Sarasota on March 28, 1979. *Courtesy Mrs. J.C. Cash and Sam Montgomery.*

About the Author

Jeff LaHurd moved to Sarasota in 1950 at the age of five. He is a board member of the Alliance for Historic Preservation, a former member of the Sarasota Historical Society and is a History Specialist for Sarasota County. He writes the popular "Quintessential Sarasota" column for *Sarasota Magazine*. His video, *Sarasota: Landmarks of the Past*, has been shown on the History Channel and won him the Florida Trust for Historic Preservation Award for Communication in 1993. He and his wife, Jennifer, have four children.